POSTCARD HISTORY SERIES

Worcester

POSTCARD HISTORY SERIES

Worcester

Frank J. Morrill, William O. Hultgren,
and Eric J. Salomonsson

Published by Arcadia Publishing
Charleston SC, Chicago IL, Portsmouth NH, San Francisco CA

Printed in Great Britain

Library of Congress Catalog Card Number: 2005926071

For all general information contact Arcadia Publishing at:
Telephone 843-853-2070
Fax 843-853-0044
E-mail sales@arcadiapublishing.com
For customer service and orders:
Toll-Free 1-888-313-2665

Visit us on the internet at http://www.arcadiapublishing.com

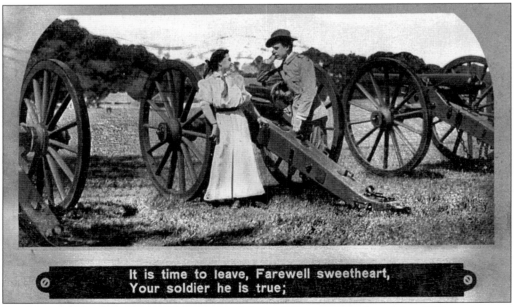

Sentiments of the times were often expressed through postcards, such as this *c.* 1911 sentimental farewell vignette.

CONTENTS

ACKNOWLEDGMENTS

The postcards in this book are drawn primarily from the collections of Frank J. Morrill and Eric J. Salomonsson. The authors would like to thank Cynthia Cooper and William O. Hultgren for accenting areas of the book with additional images.

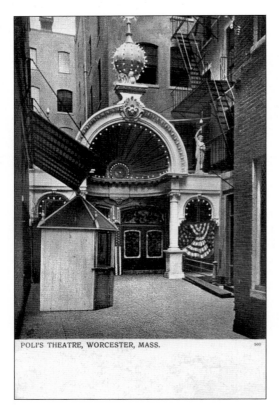

POLI'S THEATRE, WORCESTER, MASS.

This theater, located on Mechanic Street with an ornate entrance on Front Street, entertained generations of Worcester theatergoers. With the introduction of motion pictures, theaters sprang up in towns throughout the country, and Worcester was no exception.

INTRODUCTION

America's love affair with the postcard was in full swing by the beginning of the 20th century. Postcards were the equivalents of e-mail in their day. By the late 19th century, many European nations had issued early versions of postal mailing cards, and picture cards had been issued in limited quantities. In 1873, the Post Office Department began issuing pre-stamped 1¢ postal cards as a cheap way of sending a short message. Souvenir and advertisement cards were privately printed with increased frequency, but these cards had to be mailed at the letter rate of 2¢. In May 1898, Congress allowed privately printed cards marked "private mailing card," "souvenir card," or "correspondence card" to be mailed for 1¢. Three years later, in March 1901, Congress allowed publishers to use the universal term "postcard." With regulations eased, the production of picture postcards mushroomed. The majority were printed in Germany, which led the world in lithographic printing techniques. Germany maintained this domination until World War I.

Invitations, greetings, or small notes could be sent cheaply via decorative postcards. The cards were delivered quickly, and people could carry on an ongoing conversation by sending postcards. This novel mailing method started a postcard-collecting craze. Friends and family often traded cards. "Your most welcome cards received and very pleased to hear from you," wrote C. Cashman of Worcester to Mr. J. Boal of Utah in 1911. In return, Cashman sent his friend a postcard of St. Ann's Church and noted, "This is a view of the church I attend." Locally, news of interest was exchanged in brief updates. Mr. D. J. Cronin of Boston received one such postcard in August 1907 from "M. M. S." of Worcester, who noted, "The Prince of Sweden will visit here today; at City Hall this afternoon." Postcard collecting, known as deltiology, became immensely popular; postcards seemed to make the world feel smaller.

At the beginning of the 20th century, Worcester was an industrial powerhouse, and products made within its borders could be found all over the globe. The introduction of the railroad in 1835 had assured Worcester's success as an industrial city; within 20 years of the railroad's arrival, the foundations of industry had been laid. As the city's industries evolved, the developing metal and machinery outfits slowly surpassed earlier manufactories, such as the boot and shoe concerns. The greatest gains were made in the wire industry. By 1870, the city ranked as one of the largest wire-producing centers in the nation.

In 1895, Worcester was one of the largest inland industrial cities in the United States. The city housed the nation's largest loom works and envelope factory, as well as the world's largest wire complex. Five years later, Worcester was ranked the 29th largest city in the United States. With a population of 118,421, it was one of the fastest-growing communities in the state. This

blossoming population owed much of its growth to immigration. Workers flocked to Worcester to work in its diverse industries. In turn, postcard communication increased rapidly, as loved ones kept in touch between Worcester and the rest of the world.

What makes the story of Worcester industry so unusual is the way in which it progressed. Unlike single-industry towns such as Lynn or Lowell that relied upon the boot and shoe industries, Worcester became the center of a great and diversified industrial base. Spurred on by its geographical location in the center of the state, which assured cheap rail-freight costs, the city by 1914 had an estimated 2,500 manufacturing concerns employing about 30,000 people. A unique system of small and medium-sized shops developed, most of which employed no more than 100 persons. Only two great manufacturing concerns developed: Norton Company and the American Steel and Wire Corporation.

By the early 20th century, Worcester industries were producing the largest variety of manufactured goods in the nation. City companies were turning out wrenches, lawn mowers, carpets, pool tables, underwear and ladies' corsets, emery wheels and abrasive products, pistols and shotguns, barbed wire and related wire products, bricks, ice skates and roller skates, valentine cards, beer, stained glass, looms, and envelopes. The nation's largest carpet and skate manufacturers were located in Worcester. The city's board of trade promoted the local economy with slogans such as "Worcester-Made Invites Trade" and "Do it for Worcester."

Postcards portrayed the city's central business district and downtown, as well as its municipal buildings, hospitals, and churches. Numerous views of the well-maintained parks and of Lake Quinsigamond were reproduced en masse. White City became a popular postcard subject; dozens of scenes depicted the heady atmosphere of the area's premier amusement park.

Every craze reaches a peak, and by 1920, postcard mania had subsided somewhat, although stamped postcards have always remained a prominent feature of American philatelic history. Electronic technology now allows Americans instant access to friends and family worldwide. Despite these advances, however, nothing gladdens the heart quite like a postcard. It remains to this day a wonderful way of saying "thinking of you."

One

HISTORICAL REVIEW

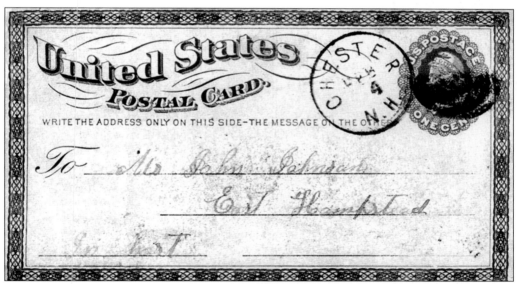

The following representative sample of cards illustrates the evolution from U.S. postal cards to private mailing cards to postcards. A postal card was issued by the government and had a prepaid postage printed on it in various colors. A postcard is privately produced and requires the sender to place a stamp on it. Early postal cards were most often used for such things as commercial ads and business headings. This U.S. postal card was the first type issued. There was no picture on the front, allowing the address to be placed there. The entire back was used for a message, unlike private postcards prior to 1907. This card was issued on May 13, 1873, and was a buff-colored card with a brown 1¢ stamp depicting the bust of Liberty.

This card was issued on September 30, 1875, and was printed on buff-colored paper with a black 1¢ stamp of the bust of Liberty. These cards were very popular and were used by businesses and private correspondents.

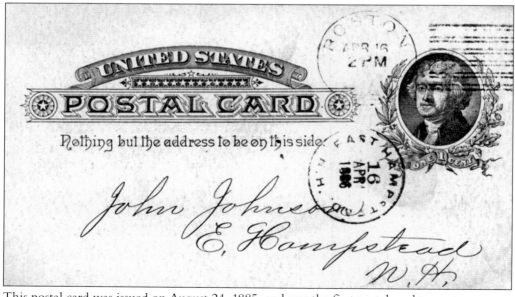

This postal card was issued on August 24, 1885, and was the first postal card to commemorate a president. This buff-colored card was issued with several color variations of brown printing. This particular card has a reddish-brown 1¢ stamp of Thomas Jefferson.

This buff-colored postal card, issued on December 1, 1886, exhibited the unusual right-facing image of Thomas Jefferson in black ink.

The Post Office Department tried a new smaller size as one variation of this grayish-white colored card, issued in December 1891. It was printed with a blue 1¢ stamp of Ulysses S. Grant. The smaller size was not particularly popular, and it went out of production in the following years.

This light buff-colored card with a black 1¢ stamp of Thomas Jefferson was issued on December 1, 1897. Jefferson's name appeared at the bottom of the stamp.

Issued on April 3, 1910, this card was one of many that commemorated Pres. William McKinley, who was assassinated in 1901. The blue 1¢ stamp bore his likeness and name and was printed on an uncommon bluish paper. Many cards were issued to pay honor to McKinley and other presidents.

The era of the private mailing card lasted from May 19, 1898, to December 24, 1901. These cards had an undivided back and a space for a message on the front. Often the image on the front was positioned to allow space for writing, as is seen on this card.

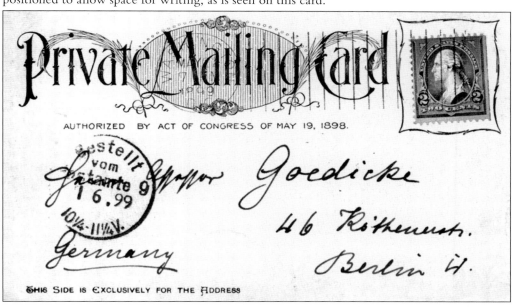

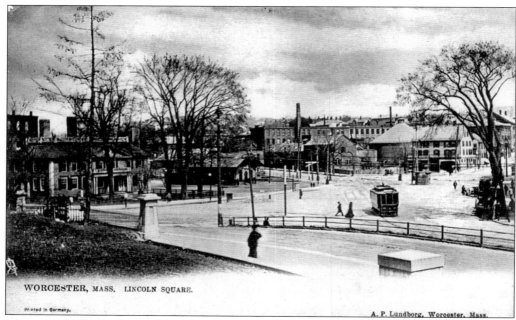

WORCESTER, MASS. LINCOLN SQUARE.

Printed in Germany. A. P. Lundborg, Worcester, Mass.

Beginning on December 24, 1901, the U.S. government permitted the use of the words "postcard" or "post card" on the backs of cards, but writing was still permitted only on the front in the white space beside the image. In this view of Lincoln Square, the small white message space is at the bottom; the back is undivided. In 1902, England allowed the divided back to be used for both the address and the message. France followed suit in 1904, as did Germany in 1905 and the United States on March 1, 1907. Placing the writing on the back and only the image on the front made these cards very collectible.

14

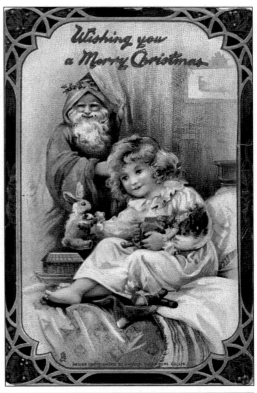

This rare Christmas card is a fine example of a divided-back postcard published in England. Most early-20th-century postcards were published in Germany, the recognized world leader in lithographic processes.
By 1910, collecting picture postcards was the largest collecting hobby ever known. The official figures from the Post Office Department for the fiscal year ending June 30, 1908, show that 677,777,798 postcards were mailed that year. That figure is more amazing when one considers that the population of the United States at that time was about 89,000,000.

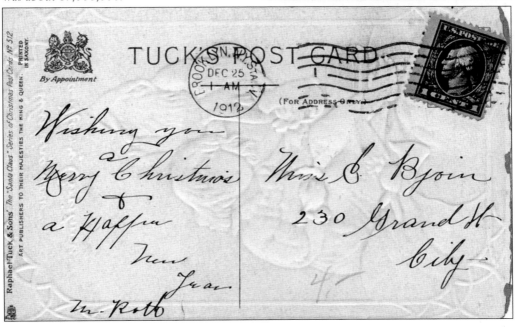

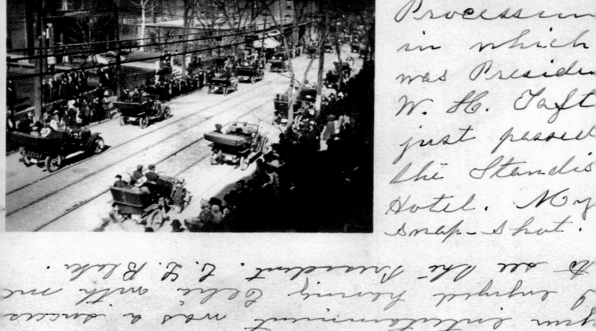

Postcards were not only commercially produced; amateur photographers could develop prints of their own, producing novel "real-photo" postcards. These postcards had real photographs and were usually printed on film stock paper. Real-photo cards are very desirable to collectors. C. L. Blake produced this card with a snapshot of Pres. William Howard Taft's motorcade passing the Standish Hotel in 1910. The message reads "Procession in which was President W. H. Taft, just passed the Standish Hotel. My snap-shot. Your letter received, very glad your entertainment was a success. I enjoyed having Celia with me to see the President."

Two

GREETINGS OF THE DAY

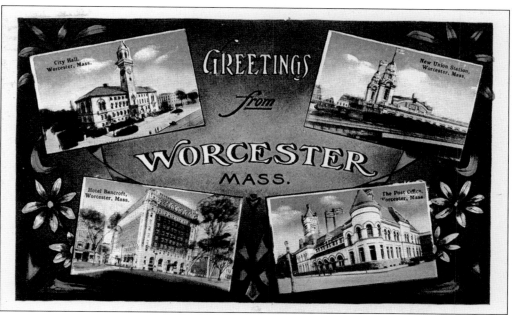

This very popular greeting postcard, sent from Worcester in 1915, allowed the recipient to get a glimpse of the important landmarks in the city at the beginning of the century. Greeting cards became extremely popular and were available for nearly all locations in the United States.

Mrs. W. C. Perry of Rockland, Maine, received this card from Worcester for the New Year in 1908.

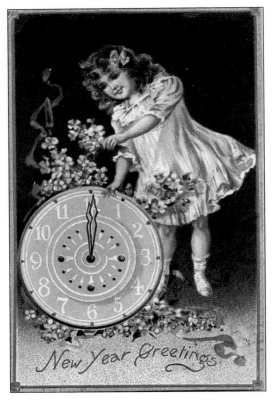

This New Year greeting card features a little girl placing flowers around the clock as it strikes midnight. Placing children on greeting cards was very fashionable. These cards provided a quick and inexpensive way to wish friends and relatives a happy New Year.

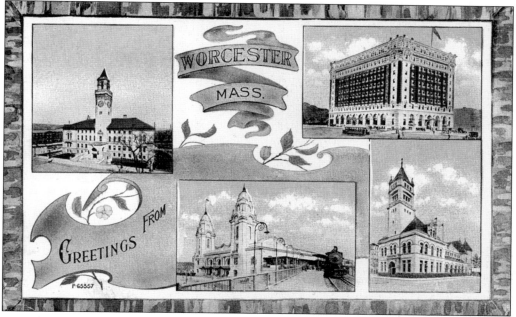

Several of the city's most modern landmarks were featured in this *c.* 1914 general greeting card. Pictured clockwise from left to right are Worcester City Hall, Union Station, the post office at Franklin (now Federal) Square, and the prestigious Bancroft Hotel. These buildings were often featured prominently on postcards of the era. This postcard is the front cover of a "postcard folder," which contained many full-sized scenes of the city. This particular folder was published by J. I. Williams of Worcester. Even though it contained many cards, it was still mailed for 1¢.

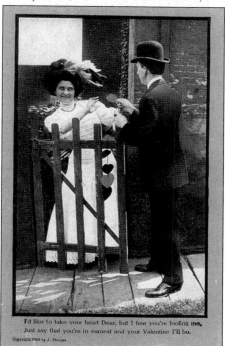

Worcester is credited with being the home of the first Valentine card, a phenomenon that spread rapidly across the country. Today, Valentine's Day accounts for nearly $700 million in gift and card sales. This uncommon postcard from 1908 depicts a man asking a girl to be his valentine.

I'd like to take your heart Dear, but I fear you're fooling me, Just say that you're in earnest and your Valentine I'll be.
Copyright 1908 by J. Thomas

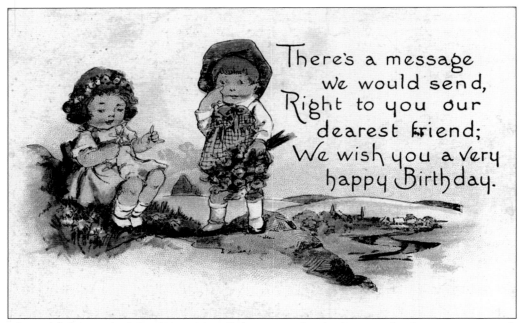

This card, postmarked April 21, 1925, illustrates another leading use for the penny postcard. The poem and the cute little girl and boy on the front were sure to bring a smile to the face of the recipient. The sender was able to place additional birthday wishes on the back.

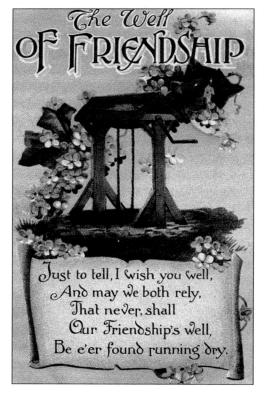

Writing letters was a leading form of communication in the early 20th century. Sometimes, correspondents wanted to drop a note with words of friendship, love, or loneliness. This postcard, sent June 15, 1910, shared words of friendship from Aunt Nellie to her niece Mabel.

In this World War I–era card, the sailor sent a clear message to his loved one that he wanted to be remembered while he was away. During World War I, many millions of postcards kept family and loved ones in touch, if only for a fleeting moment.

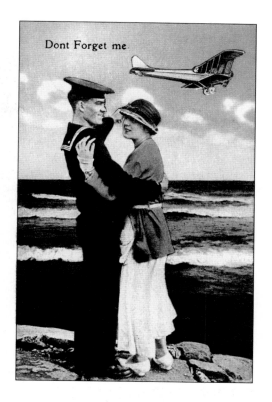

Dont Forget me

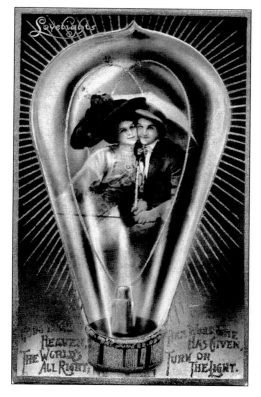

This 1910 postcard, titled "Lovelights," gives today's viewer a glimpse of the Edison light bulb of the time. Messages began to be portrayed through the images, as well as the words. This man states that his loved one's words have "turned on the light."

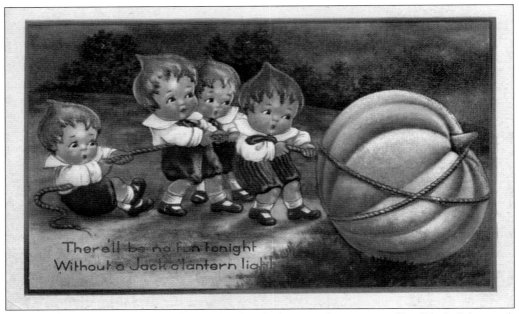

This early Halloween card is a fine example of what is today a very collectible holiday card. Halloween cards were produced in smaller numbers, many being signed, and are some of the most sought-after cards by collectors.

This patriotic Thanksgiving card is yet another example of the greeting cards that were sent between friends and relatives throughout the United States. Every holiday became a reason to get in touch with friends and family, and the 1¢ postcard offered a colorful and inexpensive way to communicate.

Three

COMMERCIAL AND
INDUSTRIAL BUILDINGS

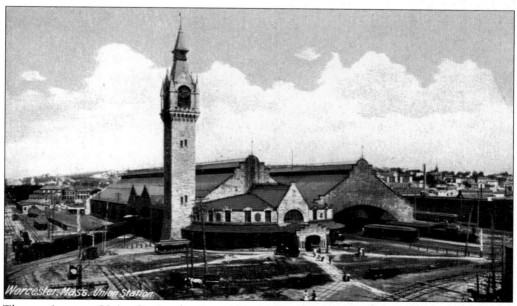

The massive stone Union Station dominated Washington Square from its erection in 1875 to 1911. Nine railroads used the station, including the "dummy train" of the short line, the Worcester & Shrewsbury. Each year, thousands of passengers embarked at the old Union Station. It was replaced in 1911 with the current Union Station. The old landmark tower was demolished in 1959 with the building of the Worcester Expressway, Route 290.

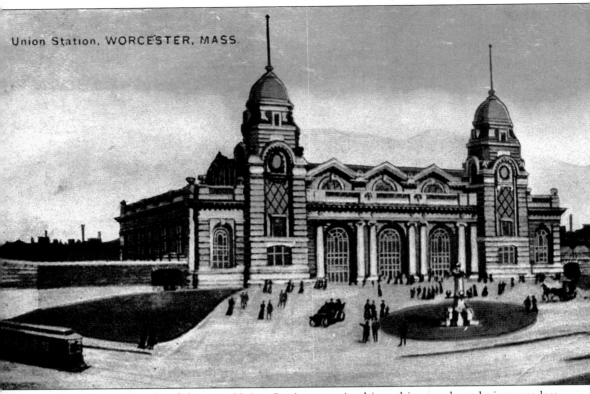

Union Station, WORCESTER, MASS.

The proposed façade of the new Union Station seen in this architectural rendering was less ornate than the final product. The station was built in the Beaux Arts style by the Boston & Albany Railroad to handle nine railroad lines. The station, with its two high towers, cost $1 million to complete. These towers were taken down several years later because of instability. With the restoration and reopening of the station in the late 1990s, the towers were rebuilt with modern materials.

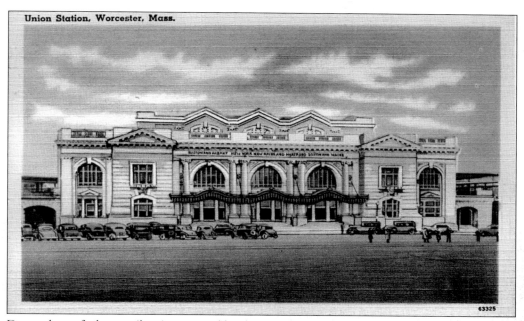

Deemed unsafe due to vibrations caused by the trains, the station's twin towers, designed in the Baroque style, were dismantled in 1926 and capped with a decorative pediment. The station is pictured here in 1944. The war brought an increase in train service, but by the late 1940s, rail transportation was being supplanted by the automobile. Union Station train service ended in 1965, and the building was abandoned in 1972 and restored in 1997–1999.

This is a fine view of Washington Square and the two railroad depots, old and new. On the left is the tower of the 1875 station, and beyond is the 1911 station. This photograph was taken shortly after the opening of the new station and the demolition of the cavernous old train shed. The stone blocks from the demolished shed were purchased at half price by Reverend Ekstrom of the Swedish Evangelical Lutheran Church and were used in the construction of the new Lutheran church on Belmont Street, today's Our Lady of Fatima Church. The old station's tower remained until 1959. After years of abandonment, Union Station has been restored to its former beauty and is an important rail connection to Boston.

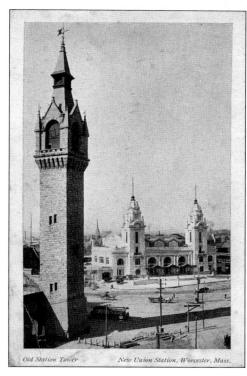

Old Station Tower New Union Station, Worcester, Mass.

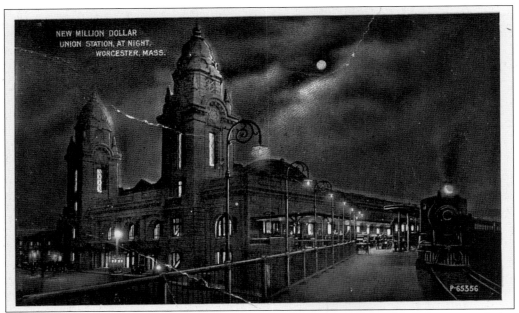

Night views are not common. This view shows Union Station at night, with the station lights shining and a late train on the platform. Note the commentary on the card, which tells of the "new million dollar Union Station." The station was open 24 hours a day to accommodate late travelers.

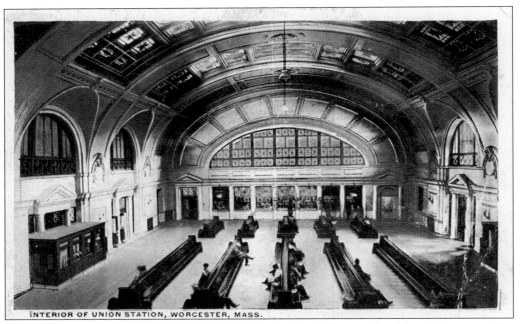

The interior of the new Union Station contained a cavernous but comfortable waiting room. For generations, arriving and departing passengers provided a lucrative business for the five major train lines that serviced the city. A rehabilitation of the building from 1997 to 1999 returned the derelict station to its former glory.

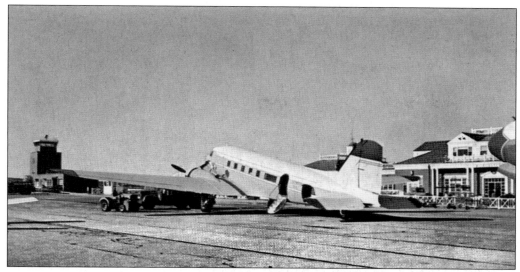

A commercial airliner awaits passengers in this 1950s postcard view of the Worcester Municipal Airport. Originally located at Whittall Field in North Grafton, the airport opened at its current location in 1945, and regular commercial service began a year later. By 1954, several buildings had been constructed, including the terminal building, which housed offices, lounges, and a restaurant. It was replaced with a new terminal in the 1990s. Despite improvements, the airport today remains largely unused, with no regular commercial service, and is mired in controversy over a proposed access road.

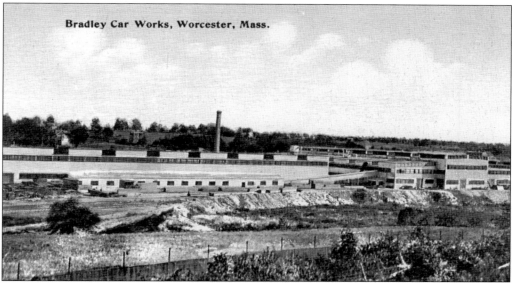

Bradley Car Works, Worcester, Mass.

The Osgood Bradley Company was the world's largest manufacturer of railroad coaches and carriages. The 18-acre plant, located on 52 acres in the Greendale section of the city, opened in 1909 and employed 1,500 workers. Osgood Bradley began making coaches in 1833 and manufactured the first railway passenger coach in New England. The business was carried on by his son Harry Osgood and his grandson John E. Bradley. The decline in the railroads after World War II was hard on the industry. The buildings were sold, and some were demolished. Today, small enterprises and a cinema occupy the site.

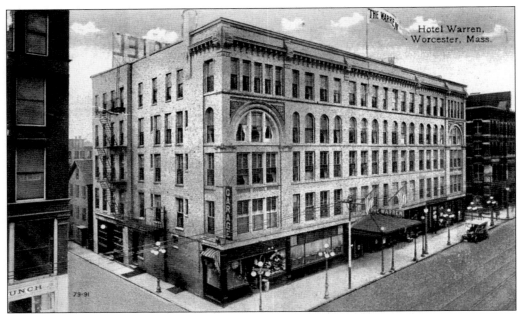

The Warren Hotel, built in 1902 as the Commonwealth Hotel, was located in a five-story brick building at 201 Front Street. Ransom F. Taylor purchased the Commonwealth in 1905 and, following major alterations, reopened it as the Warren. Its proximity to the railroad station made it a popular stop for visitors and travelers.

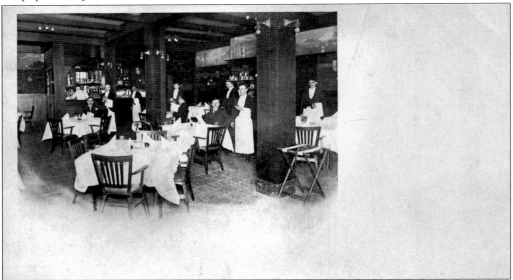

This is an interior view of the Hotel Warren's Grille Room and its attendant waiters. In 1930, the owners, brothers Rudolph and John Drescher, experimented with a novel scheme: "waiterless dining." Each table had a platform in the middle, on which diners, after selecting their meal from the menu, placed their selection card. The order was lowered on the platform to the kitchen below, where it was filled, and the food rose to the table on the same platform. Payment was made to the cashier on the way out. How long this experiment lasted is unknown, but the Hotel Warren was no longer in business by 1940. The Worcester Common Outlets now occupy the site.

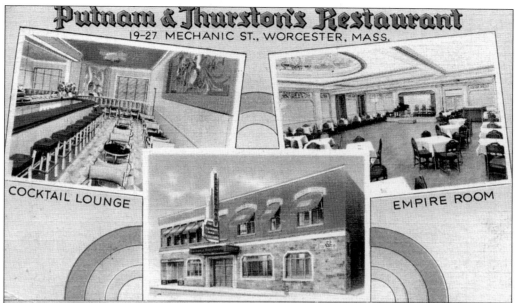

Putnam & Thurston's Restaurant

19-27 MECHANIC ST., WORCESTER, MASS.

COCKTAIL LOUNGE

EMPIRE ROOM

ESTABLISHED 1858 WORCESTER'S LARGEST RESTAURANT AIR CONDITIONED

For well over a century, Putnam and Thurston's Restaurant on Mechanic Street was one of the more popular eateries in the city. Its numerous banquet rooms were popular destinations for both private and social affairs, and its cocktail lounge attracted a steady clientele from the downtown business district.

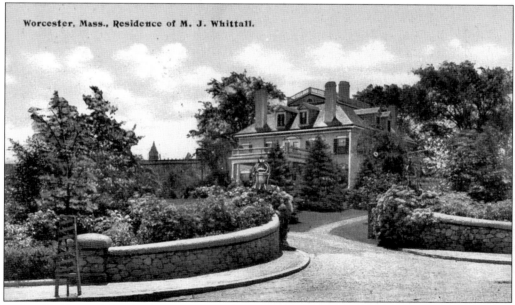

Worcester, Mass., Residence of M. J. Whittall.

At Southbridge and Cambridge Streets was the imposing Georgian Revival mansion of Worcester's largest carpet manufacturer. M. J. Whittall emigrated from Great Britain and found employment in the Crompton Carpet Mills. He decided to go into the carpet business for himself, building his first mill in 1882 and six others by 1906. The company operated until it was sold in 1950. Rotman's Furniture, adjacent to route 290, occupies the factory buildings today.

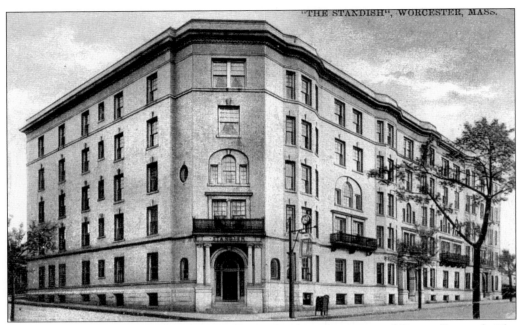

The five-story Standish Hotel opened in 1900 under the management of George Bancroft. The hotel contained single rooms, apartments, and the clubhouse of the Square & Compass Club, a Masonic organization. In 1925, the hotel on Main Street was sold. The new owners offered long-term leases rather than overnight accommodations. As the neighborhood declined, the hotel became derelict.

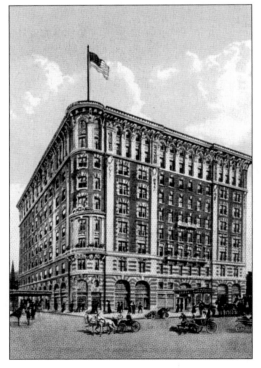

There were several hotels in Worcester in the early 20th century, but the outstanding luxury hotel was the Bancroft Hotel. Built in 1911–1912 by a realty company headed by Alfred Aiken, the Bancroft is an imposing site on the common. Its 320 rooms provided excellent accommodations for guests, and facilities included rooftop dancing and banquet facilities patronized by the city's social set. The hotel has been renovated and today houses apartments and commercial space.

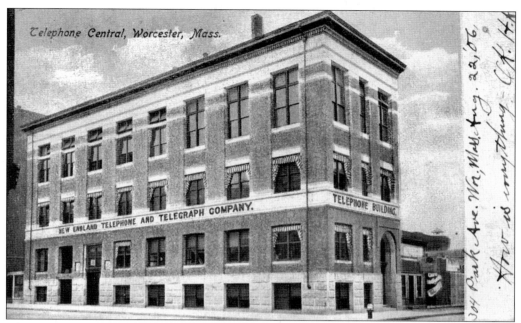

Telephone Central, Worcester, Mass.

The New England Telephone and Telegraph Company was located at 26 Mechanic Street from 1893 to 1930. The first telephones were introduced in the city in 1879, with an exchange at 425 Main Street; there were 75 subscribers. By 1888, long-distance service had been introduced. With the number of subscribers growing yearly, two stories were added to the Mechanic Street building in 1913. The new telephone building on Chestnut Street was opened in 1930, when the conversion to dial telephone service was made.

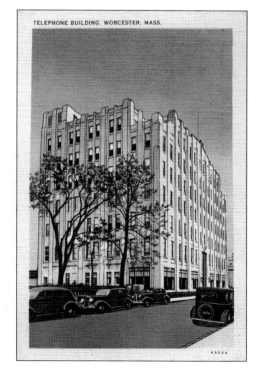

TELEPHONE BUILDING, WORCESTER, MASS.

This 1939 postcard presents a good view of the new telephone building on Chestnut Street. A larger addition was constructed in the 1950s to handle burgeoning communication demands.

31

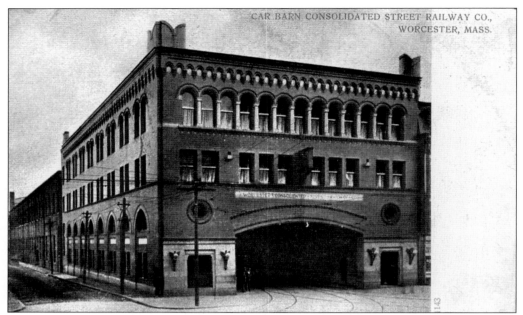

This view shows the Worcester Consolidated Street Railway's carbarn at Main and Market Streets. The carbarn was built in 1903 to service and repair the trolley cars that traveled over a network of rails throughout the city and county. The company offices were in the upper floors of this Romanesque Revival building. After 82 years, trolley service in Worcester ended on New Year's Eve of 1945. This building was torn down and replaced in 1980 by the Marriott Hotel, now the Crown Plaza Hotel.

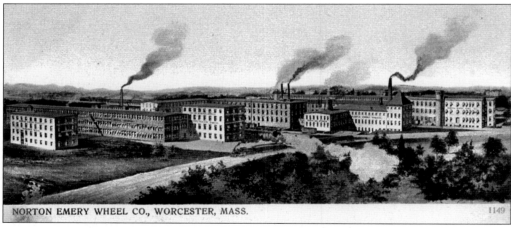

NORTON EMERY WHEEL CO., WORCESTER, MASS.

Norton Company was begun as a pottery shop on Water Street by Frank B. Norton. John Jeppson, a Swedish immigrant potter, arrived in Worcester in 1869 and began to work for Norton. The firm was acquired in 1885 by several businessmen and was moved to the Greendale section of the city. With Jeppson as superintendent, the company flourished. The introduction of a Jeppson development, the emery grinding wheel, made Norton Company the world's largest manufacturer of abrasive grinding wheels. The company encouraged the hiring of Scandinavian and Italian immigrants; by World War I, company pay vouchers were printed in English, Swedish, and Italian. Now known as Saint-Gobain, the company remains one of the region's prime industrial businesses.

32

Crompton and Knowles Loom Works, once the world's largest manufacturer of textile looms, was located at 93 Grand Street and employed 2,800 workers at its peak in 1950. In 1837, William Crompton received a patent for "an improvement in figure or fancy looms." Lucius Knowles began producing textile looms in 1884. The two firms merged in 1897. The large brick factory seen here was built in 1890 for Crompton by Darling Brothers of Charlton. Due to strong foreign competition and the dramatic loss of textile plants in New England, manufacturing ended at the Crompton and Knowles plant on July 1, 1980, after 143 years.

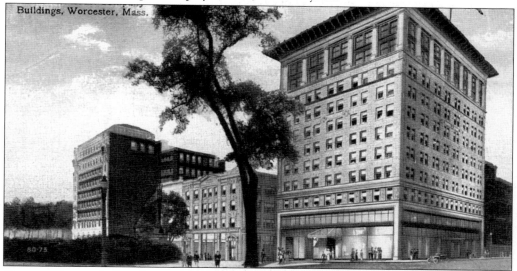

One of Worcester's first skyscrapers, the Park Building, and its neighbor, the Worcester Trust Company Building, are the subjects of this 1915 postcard. The new Bancroft Hotel is the next building beyond. The view is from the front of city hall looking toward Franklin Street (formerly Park Street). The Park Building was built by a consortium of businessmen to replace a group of three- and four-story business blocks. The Worcester Trust Company, the first trust company licensed in Massachusetts, was incorporated in 1868, with George M. Rice as its first president and 11 Main Street as its first headquarters. The company moved to the new State Mutual Building in 1903, remaining there until a new home was built in 1915.

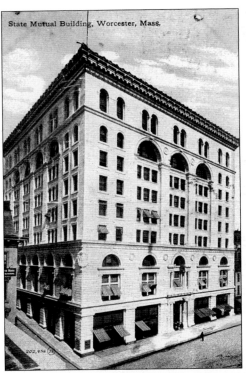

State Mutual Building, Worcester, Mass.

The imposing new State Mutual Life Assurance Company Building was located on Main Street. Constructed in the 1890s of white marble attached to a steel frame, it was designed by Peabody and Stearns of Boston and built by the Worcester-based Norcross Brothers Company. For several years, it was Worcester's only skyscraper.

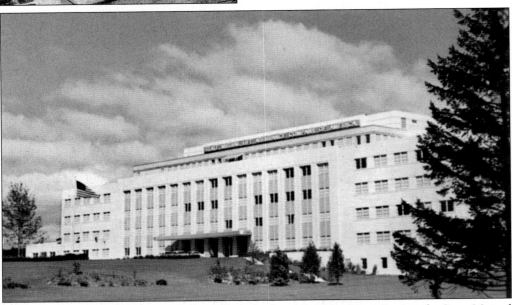

After over a century of doing business within the downtown business district, the State Mutual Life Assurance Company constructed an impressive modern office building on Lincoln Street in the late 1950s. One company publication stated, "Many years of planning by our Board of Directors, our staff and the finest in architectural and construction talents have resulted in a Home Office which symbolizes, we believe, the growth and future of the American insurance industry." The company now operates under the Allmerica Financial banner.

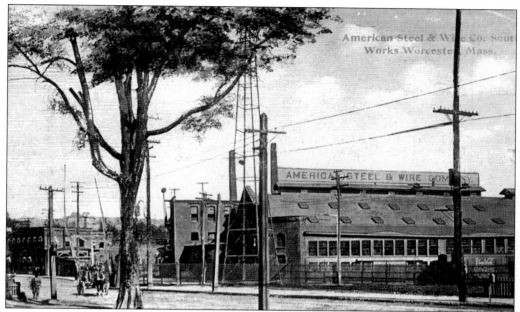

American Steel & Wire Company was formed in 1899 from the Washburn & Moen Wire Works. The world's largest producer of wire fencing and domestic wire products had two factory locations: one was on Grove Street and the other, the south works, seen here, was on Millbury Street in Quinsigamond Village. Business declined after World War II, and the south works ceased operations in Worcester. The Grove Street factory has been adapted to various uses, and the south works buildings have been demolished.

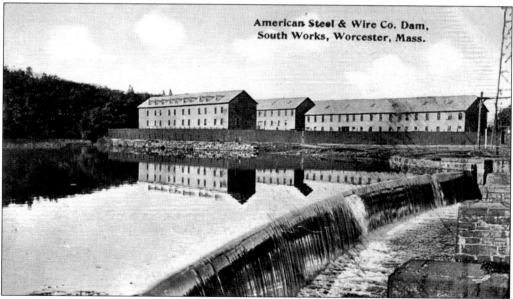

Manufacturing operations at this site and at the south works mill in Quinsigamond Village ceased in the 1970s. The factory buildings have been demolished, and this site is being developed as part of the revitalization of Quinsigamond Village. The rebirth of the Blackstone Heritage corridor and the Blackstone Canal are included in this plan.

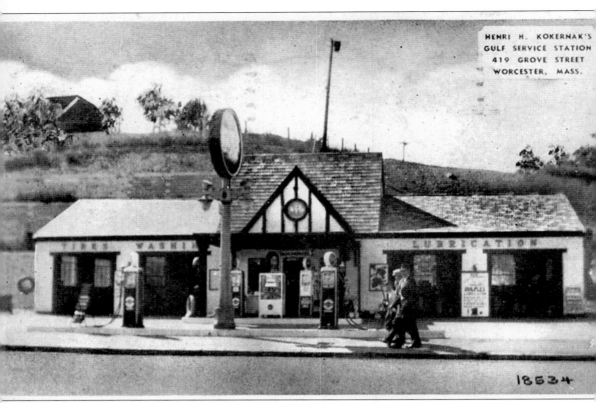

HENRI H. KOKERNAK'S
GULF SERVICE STATION
419 GROVE STREET
WORCESTER, MASS.

18534

For well over 30 years, Henri Kokernak operated a service station in the city. His well-maintained Gulf Service Station, at 419 Grove Street, is shown here in a 1940 view. At this time, he and his wife, Mildred, lived just down the street at 401 Grove Street.

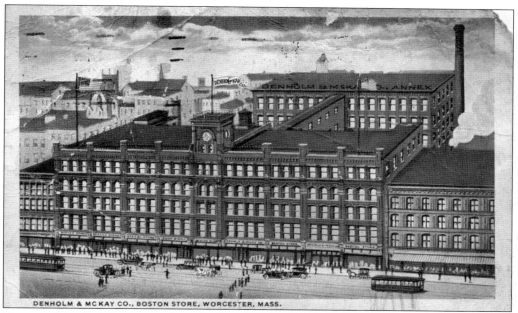

DENHOLM & MCKAY CO., BOSTON STORE, WORCESTER, MASS.

Worcester's leading department store, the Denholm & McKay Company, occupied the Clark block opposite city hall. Opened in 1870, the sprawling retail complex was a Main Street landmark. A radical face-lift was completed in the early 1950s, leaving this façade unrecognizable. After a brief move to the suburban Auburn Mall, the company declared bankruptcy in 1973 and closed.

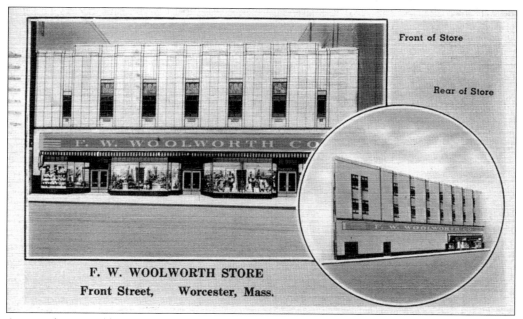

Front of Store

Rear of Store

F. W. WOOLWORTH STORE

Front Street, Worcester, Mass.

Among the several large department stores that once graced the downtown business district was F. W. Woolworth, at 22–24 Front Street, seen here in a 1944 view. The building later became home to the Midtown Mall and its collection of small businesses and eateries.

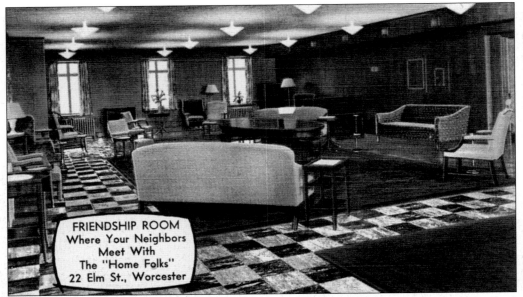

FRIENDSHIP ROOM
Where Your Neighbors
Meet With
The "Home Folks"
22 Elm St., Worcester

The Worcester Co-Operative Federal Savings and Loan Association was the largest federalized institution in New England and specialized in low-cost home loans and insured savings accounts. The institution also sponsored the *Melodies from Friends* radio program, broadcast from the association's Friendship Room. Patrons were invited to attend the program for their personal enjoyment. This type of personal service is unknown within the banking industry today.

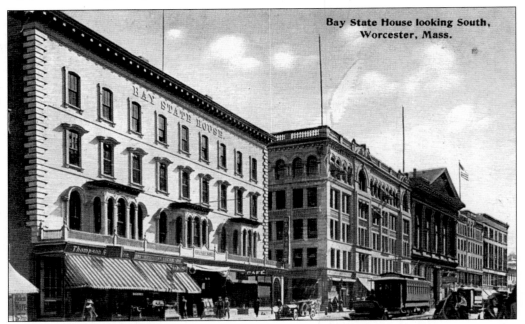

Bay State House looking South, Worcester, Mass.

The four-story Bay State House, costing over $100,000, opened on February 8, 1856. Located at the corner of Exchange and Main Streets, it was host to conventions and political speeches and featured conveniences such as steam heat. During World War II, it was reduced to two stories and used for business offices.

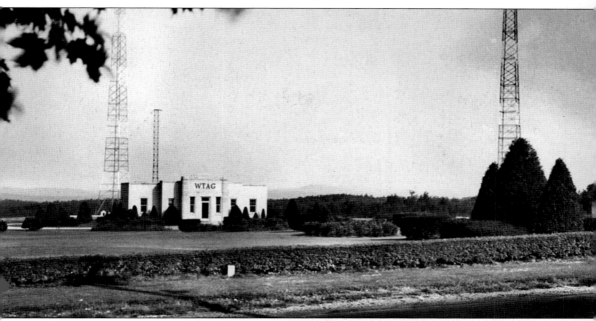

Originally owned by the C. T. Sherer Department Store and operated with the call letters WCTS, this popular local radio station was purchased by the Worcester Telegram and Gazette and given the new call letters WTAG. Shown here are the transmitter facilities, erected in the 1930s in nearby Holden on land formerly owned by C. J. Hultgren.

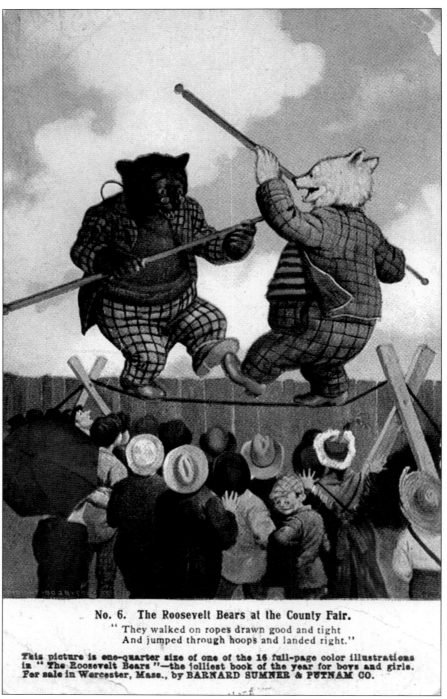

No. 6. The Roosevelt Bears at the County Fair.
" They walked on ropes drawn good and tight
And jumped through hoops and landed right."

This picture is one-quarter size of one of the 16 full-page color illustrations in " The Roosevelt Bears "—the jolliest book of the year for boys and girls. For sale in Worcester, Mass., by BARNARD SUMNER & PUTNAM CO.

Advertising on postcards was a very popular method of marketing a vast array of products. This card is a fine example of advertising in the early 20th century. The scene is one of 16 full-page illustrations in *The Roosevelt Bears*, a children's book that is being advertised for sale by Barnard Sumner & Putnam Company of Worcester.

Four

MUNICIPAL SCENES

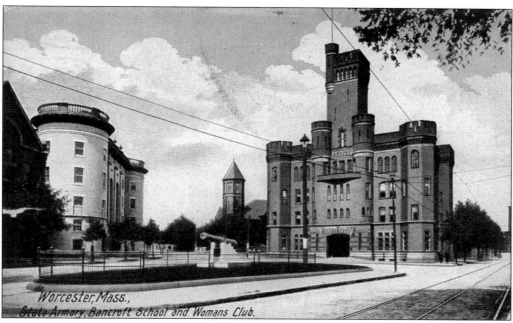

Worcester, Mass.,
State Armory, Bancroft School and Womans Club.

The Worcester Armory at Wheaton Square, earlier called Armory Square, forms part of an architecturally important cluster of civic buildings. Architects Fuller & Delano designed the armory, which was built in 1888–1889 on land purchased from Stephen Salisbury, replacing an older armory on Waldo Street. The Massachusetts Military Archives occupy part of the building today. On the right is the Worcester Boys Trade High School, built in 1909–1910 with the goal of producing "skilled and efficient workmen."

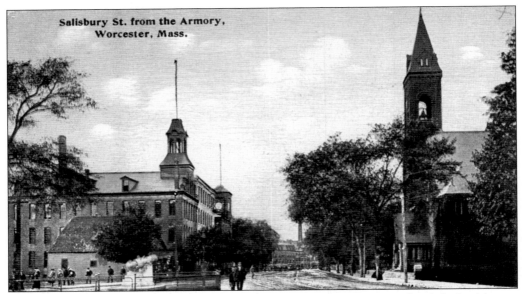

The brown sandstone Central Congregational Church can be seen on the right in this rare view from the armory on the corner of Grove Street and Institute Road. Central Church was organized in 1820, and this building was erected in 1885. The businesses and factories at Lincoln Square can be seen in the distance. On the left are factories located on the land formerly owned by Stephen Salisbury. The Worcester Boys Club and the Worcester Trade School occupy these sites today.

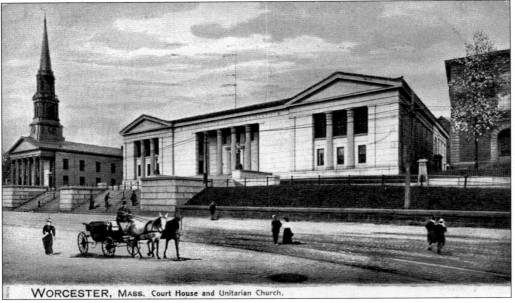

WORCESTER, Mass. Court House and Unitarian Church.

The current façade of the Worcester County Courthouse, located at Lincoln Square, is the result of a major addition in 1898 by the architectural firm of Andrews, Jacques & Rantoul. A courthouse has occupied this site since the county was established in 1731. A part of the current building was built in 1843, and it was expanded in 1878. The façade was extended in the Greek Revival style.

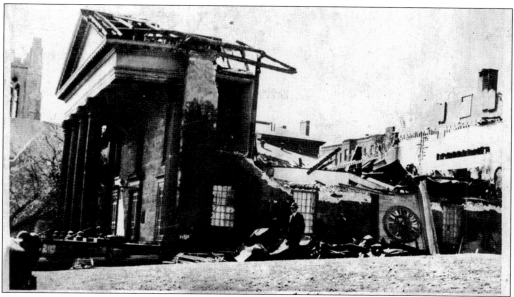

The hurricane of September 21, 1938, proved disastrous to an unsuspecting New England. Over 600 people lost their lives, and property damage mounted into the millions. In Worcester, factory fires broke out, and both Classical High School and Woodland Street School were severely damaged. The First Unitarian Church, seen here, was largely destroyed, as the steeple collapsed into the church. The edifice was rebuilt to resemble its original appearance.

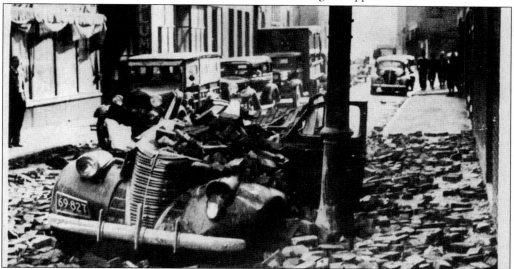

The catastrophic hurricane of September 21, 1938, blew through the Worcester area with record-strength winds and a deluge of water. The winds picked up throughout the afternoon; roofs were blown off, trees were uprooted, walls were blown over, and low-lying areas were flooded. Property damage amounted to hundreds of millions of dollars. An account of the day stated, "The tremendous fury of the wind left behind destruction, destitution and utter ruin." Transportation was at a standstill, and some public services were destroyed. Hospitals were filled with the injured, and a number of people were killed. It was Worcester's worst disaster until the 1953 tornado.

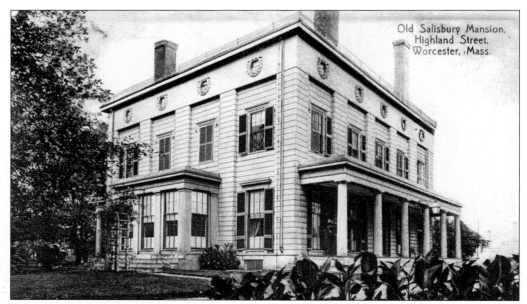

This home, sitting high above Harvard Street behind the Memorial Auditorium, was built by Stephen Salisbury II in 1836. Salisbury hired architect Elias Carter to build the house in the popular Greek Revival style. His father's old home, popularly known today as the Salisbury Mansion, was located at Lincoln Square. It was moved adjacent to his son's home in 1929. The Salisburys were one of Worcester's leading families and were prominent philanthropists.

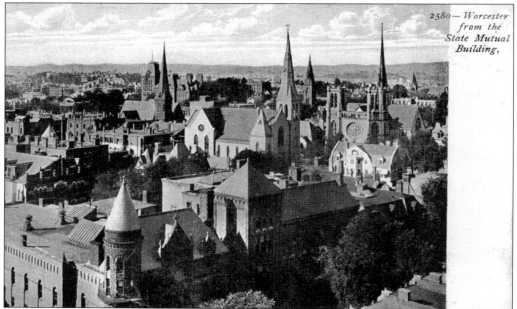

This interesting bird's-eye view looks southwest from the roof of the nine-story State Mutual Building in 1915. Church spires dominate the skyline. English High School's tower is just behind the Pleasant Street Baptist Church steeple, on the left. Plymouth (Grace) Methodist Episcopal Church is the large church in the middle, and the All Saints' Episcopal Church spire is the next one to the left. Chestnut Street Congregational Church's twin towers and spire are on the right.

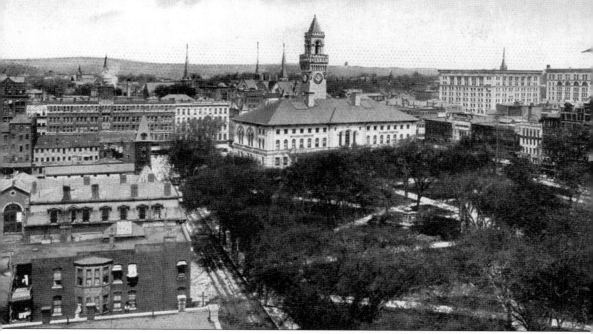

This bird's-eye view, looking west from the steeple of the former Methodist church, shows much of the downtown area surrounding the common. The prominent buildings are the newly built 1896 city hall, the nine-story 1897 Slater Building, and the 1897 State Mutual Building.

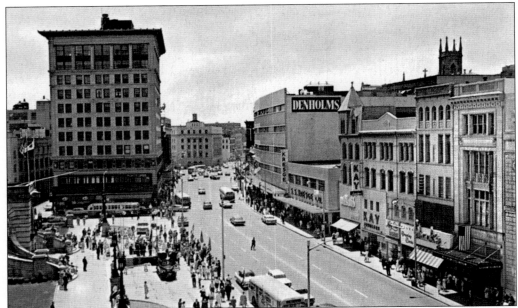

These two 1950s postcards highlight downtown Worcester. Shoppers crowd the commercial district, which was once lined with various retail and wholesale establishments. Wednesday nights were particularly popular shopping nights, as stores remained open until 9:00. The top view is of Main Street looking south. To the left is City Hall Plaza, and to the right is Main Street, lined by establishments such as Shacks, Kay Jewelers, and S. S. Kresge (now known as Kmart). The chief department store, Denholm's, can also be seen.

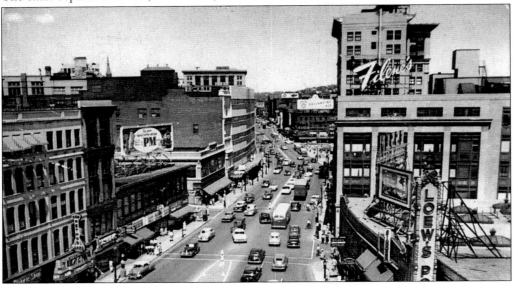

Looking north, this view of Main Street features popular landmarks such as Filene's Department Store and the Loew's Poli Theater. The decline in commercial activity in the downtown area was so sharp that, by the 1960s, only a handful of stores remained. Urban renewal and the construction of the Worcester Center Galleria in the 1970s did little to spur economic development. Downtown Worcester today remains full of potential, but it is only a shadow of its former self.

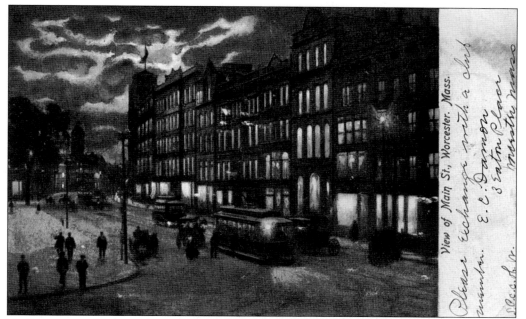

Trolley cars and horse-drawn carriages create a less busy scene of Main Street in this 1906 nighttime view.

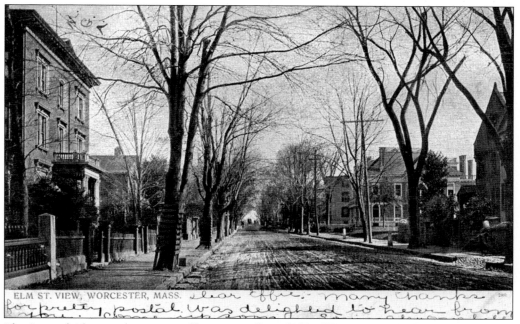

Elm Street, laid out and constructed by a team of men led by Worcester native Gov. Levi Lincoln, opened around 1834. Almost every city or town in America can boast of having an Elm Street, usually named in honor of the stately American tree that graced the nation's landscape prior to its decimation by Dutch elm disease in the early 20th century. The building to the left in this *c.* 1907 view now houses the exclusive Worcester Club.

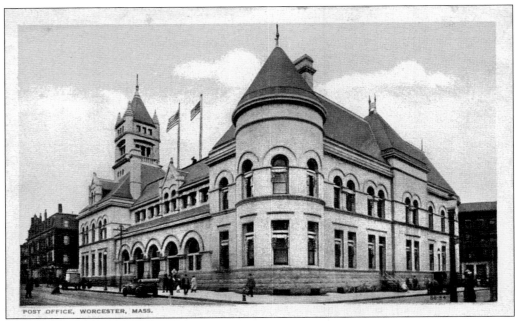

POST OFFICE, WORCESTER, MASS.

In the next series of postcards, one can journey from Myrtle Street north along Main Street to Exchange Street, viewing the city's many business blocks, crowded sidewalks, trolley cars, and bustling activity. Worcester's first post office was established on Pearl Street in 1775, with Isaiah Thomas as postmaster. The fast-growing city and its flourishing businesses made a new and larger post office necessary, and in 1895, the U.S. government purchased land between Main and Southbridge Streets and erected this chateauesque turreted building. The post office and other federal agencies occupied the building until the late 1960s, when the new post office facility was built.

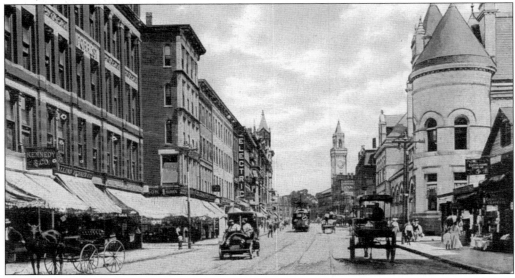

On the left, Kennedy & Company, a longtime Worcester haberdasher, occupies the ground floor of the Forbush Building. A tower housing office and residential space is now located on the site. Notice the early right-hand-drive car heading south.

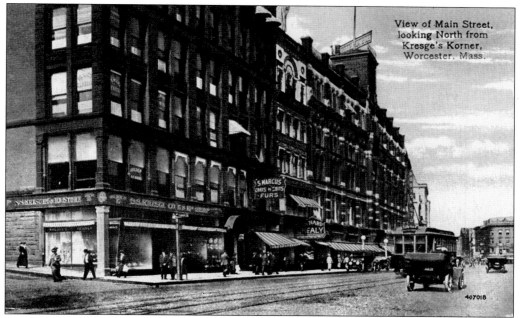

Business blocks continue north on what was once called Nobility Hill, the site of many of Worcester's elegant homes before the Civil War. The S. S. Kresge 5- & 10-cent store is located in the corner building, and Worcester furrier S. Marcus is located on the second floor. Beyond is Richard Healy Company, a ladies' dress shop.

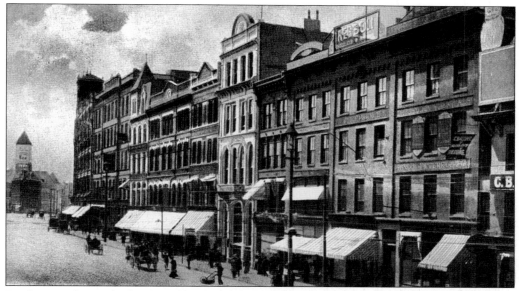

Farther north are the business blocks opposite city hall. The third building from the left is the white four-story Central National Bank Building, also known as the Enterprise Building, built in the Beaux Arts style in 1901. Moving south, the next building is the John C. MacInnes department store. The last building is its rival, the Denholm & McKay department store. The Denholm Building still stands, although its façade has been completely changed. All the buildings in the foreground are gone, and today the site is occupied by a 24-story bank tower and plaza.

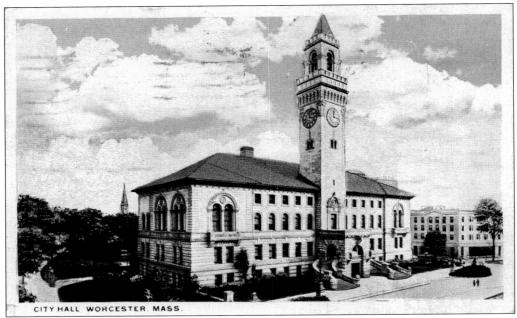

CITY HALL WORCESTER. MASS.

This scene looks southeast from the corner of Pleasant and Main Streets. The 1896 city hall was designed by Boston architects Peabody & Stearns and built of pink granite from Milford. Its 205-foot tower has a viewing area that is reached by way of an iron circular staircase. The tower's 820-pound clock has an imposing dial measuring 14 feet, 6 inches in diameter. Originally, this new city hall contained 60 rooms, all finished magnificently with oak. It replaced the 1825 town hall and the adjacent Old South Church, which had occupied the west end of the common. Both city halls stood at the same time for a brief period in the late 1890s, as the present city hall was being built.

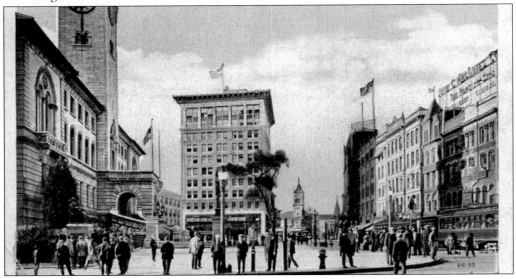

Even though the postcard states that this is a northerly view, it is actually looking south from City Hall Plaza. Visible is one of the few sky scrapers in Worcester, the 11-story Park Building, which was built in 1915.

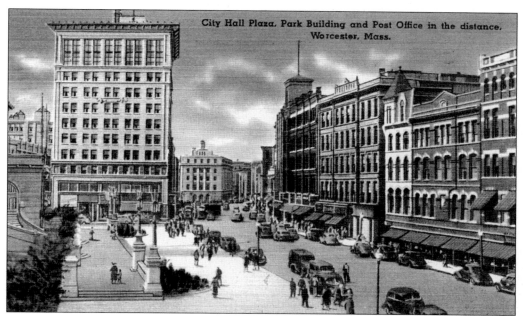

Taken from the same location, this 1942 photograph shows a much later view of the same area. Many of the buildings are the same, but one can see the vast changes in transportation.

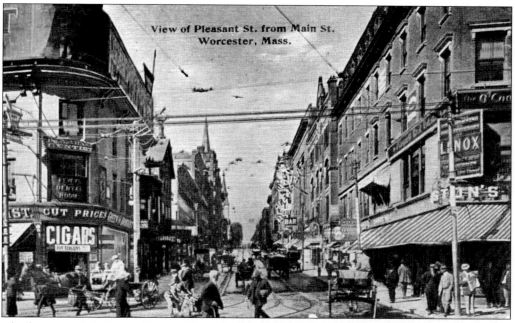

The heavy pedestrian and horse-drawn traffic at Pleasant and Main Streets is shown in this late–1890s scene. On the left is Henry L. Green's popular 24-hour drugstore. The spire of All Saints Episcopal Church is seen in the distance. Fergus Easton's newspaper and stationery store is in the Rogers Block, on the right. Opened in 1893, Easton's remained a popular spot for many years. It closed in 1964.

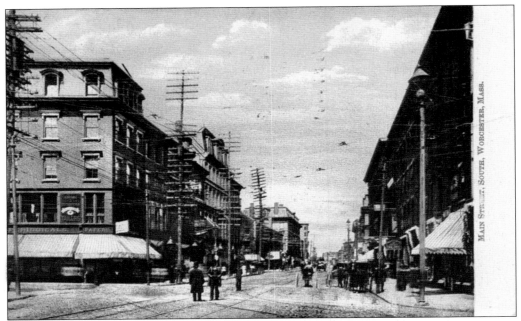

Turning right and facing north, this view shows Harrington Corner, the hub of the city for many years. On the left is the Rogers Block, built by shoe manufacturer Richard Rogers in 1869 and remodeled in 1890. This busy intersection is shown prior to 1899, when the unsightly tangle of overhead wires was put underground.

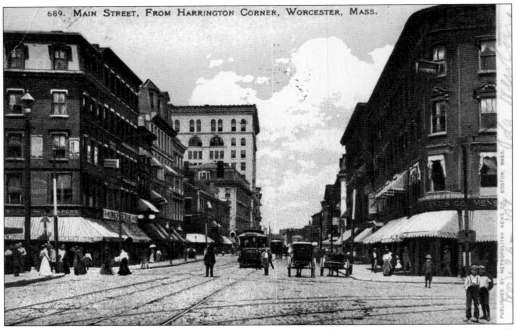

This view of the same intersection a few years later shows the 1897 State Mutual Life Insurance Building, Worcester's first skyscraper. In the distance on the right is the four-story Harrington Block.

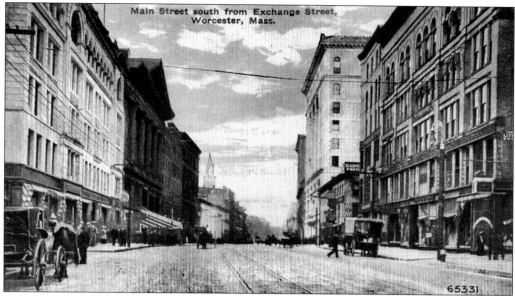

Main Street south from Exchange Street, Worcester, Mass.

65331

Moving north on Main Street, the photographer set his camera at Exchange Street to look back toward city hall. The Central Exchange Building is on the left. Built in stages between 1895 and 1902, it replaced the old Central Exchange Building of 1830. Mechanics Hall is the dark building beyond. Built in 1855 from plans by Elbridge Boyden, Mechanics Hall is noted for its outstanding acoustics. It provides a venue for performers, speakers, and musical groups. The hall was restored in 1977, after many years of decline, and was used for events such as boxing, wrestling, and roller-skating.

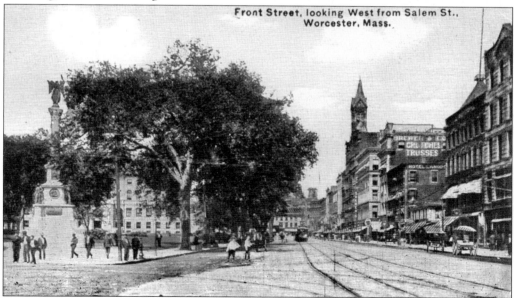

Front Street, looking West from Salem St., Worcester, Mass.

This view of Front Street can be seen in an altered form from the front entrance of the Galleria. Front Street passes the common, on the left, and leads toward Main Street and Harrington Corner. The tower of the Chase Building and businesses such as the C. T. Sherer Department Store and Brewer and Company can be seen on the right.

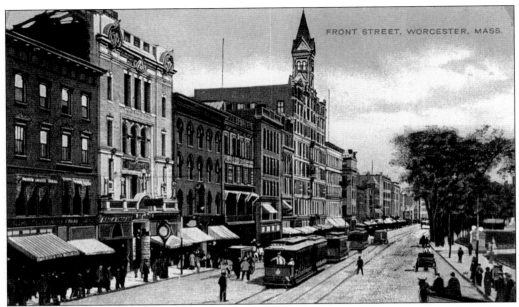

Front Street, which at one time connected city hall with Union Station, was one of the busiest streets in the city. Scores of businesses and shops catered to residents and new arrivals. In this unique view from Main Street, pedestrians crowd the sidewalks while trolleys make their way toward Main Street. The common is to the left. The tower of the Chase Building was a familiar landmark in early-20th-century downtown Worcester.

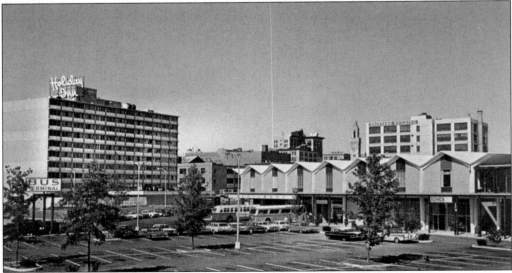

In order to maintain the economic viability of downtown, several urban renewal projects were undertaken beginning in the late 1950s. The first of these, the Seven Hills Plaza, opened in 1964. Included was a mall and an adjacent Holiday Inn. The plaza, with its myriad stores and its bus terminal, is seen here shortly after its opening. The Holiday Inn has been converted into condominiums, and the plaza now houses establishments such as Ping's Garden Chinese Restaurant. Despite the infusion of development, downtown Worcester has never recovered from losing its status as the commercial and retail center of the county.

Five

FOR THE BODY
AND SPIRIT

The New England Synod of the Augustana Lutheran Church established the Swedish Lutheran Old People's Home in 1920 in order to provide care for the elderly immigrant generation. The original building, seen here, was located in the former 1850 Henry Goulding home at 26 Harvard Street. It was purchased with a generous donation from the Jeppson family of Norton Company fame. Enlarged over the years, the Lutheran Home now provides care for individuals of all creeds and stands as a testament to the generosity of Worcester's Swedish community.

The Swedish Evangelical Lutheran Gethsemane congregation was organized in 1881 and constructed its first house of worship on Mulberry Street. Its next church, built with granite from Worcester's old Union Station, was dedicated in 1911. The congregation worshipped in this edifice until 1951, when it moved into the new Trinity Lutheran Church. This building was sold to the Diocese of Worcester and reopened as Our Lady of Fatima Church.

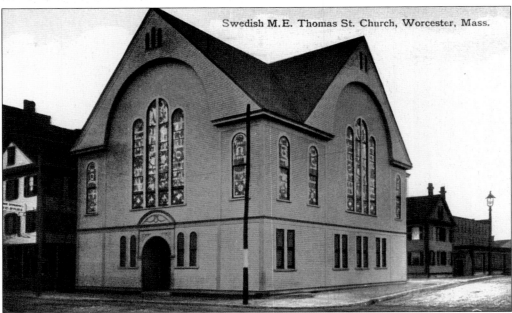

Shortly after its organization in 1885, the Second Swedish Methodist congregation purchased this church at the corner of Thomas and Commercial Streets. In the 1890s, the building underwent a complete remodeling, which resulted in the church shown in this *c.* 1910 view. Following its abandonment as a church, it became the Peterson-Varg Furniture Store. It was later demolished as part of urban renewal.

The Thule Building was erected on Main Street in 1905 as a winter quarters for many of Worcester's Swedish-American organizations. Swedish immigrants were an integral piece of the puzzle that was Worcester. This 1910 view also features the music store of Charles "Carl" Hanson, the first recorded Swedish settler in Worcester. His successful business occupied space on the first floor at the left. The building now houses Palson's Office Supply.

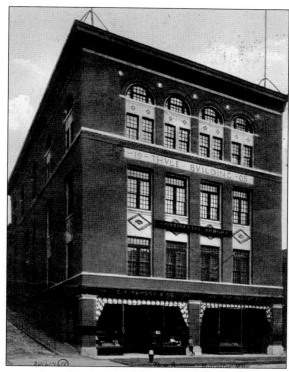

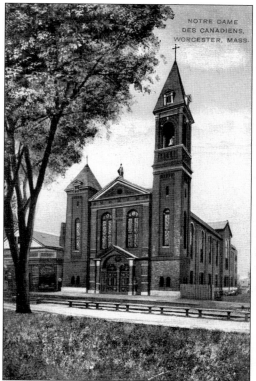

This postcard and the two that follow document the history of Notre Dame des Canadiens Roman Catholic Church, founded in 1869 by the city's French Canadian community. It was the first non-English-speaking parish established in the city. In 1870, a former Methodist church on Park Street was purchased with funds largely contributed by Notre Dame church founder Fr. Jean–Baptiste Primeau. In 1880–1881, the church was remodeled into the structure shown here.

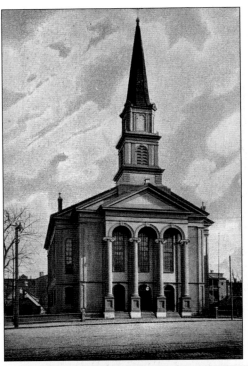

On October 14, 1908, a fire caused massive damage to buildings in the Park Street area, including Notre Dame Church. Following the fire, the parish relocated to this former Baptist church, a block away at Salem Square. The parish had purchased this edifice in 1902 for a school.

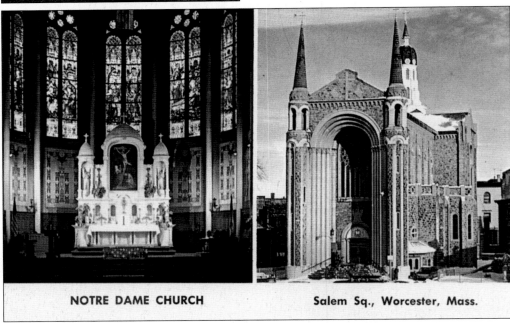

NOTRE DAME CHURCH Salem Sq., Worcester, Mass.

With the church in need of major repairs, the parish opted to construct a new edifice at the same site. Designed by Donat R. Baribault of Springfield, the church exemplified the neo-Romanesque style popular in France. It was dedicated on September 15, 1929. Notre Dame remains a downtown landmark, serving a large Franco-American congregation whose roots are in the great migration of workers from Quebec in the late 1800s.

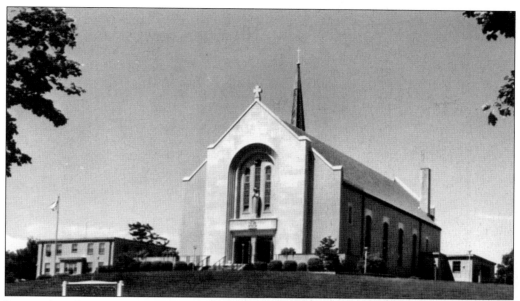

Immaculate Conception was organized in 1873 as the fifth Roman Catholic parish in Worcester. The current edifice, seen here in a 1960s photograph, replaced an earlier church located on Prescott Street. On December 8, 1956, the church cornerstone was laid, and the first Mass was celebrated on October 31, 1957. The church bell, originally located in the main fire department headquarters, was donated by the city of Worcester in memory of deceased Worcester veterans.

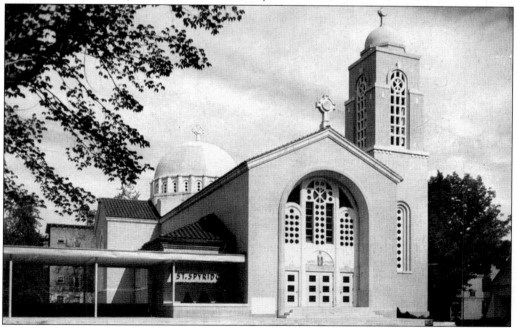

St. Spyridon Greek Orthodox Church is one of the more unusual church buildings in the city. Designed in the Byzantine architectural tradition, this unique edifice was opened in 1950 on Russell Street adjacent to Elm Park. The church remains quite active and plays host to the city's large annual Greek Festival.

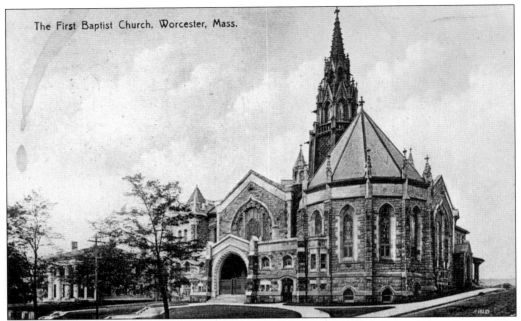

The First Baptist Church, Worcester, Mass.

The First Baptist Church, founded in 1812, built its first house of worship at Salem Square. The congregation's third church, seen in this view, was erected on Main Street at Ionic Avenue in 1907 and contained 86 rooms plus the sanctuary. This church was destroyed in a fire in 1937 and was replaced with the present congregation's home, at Park Avenue and Salisbury Street, in 1939.

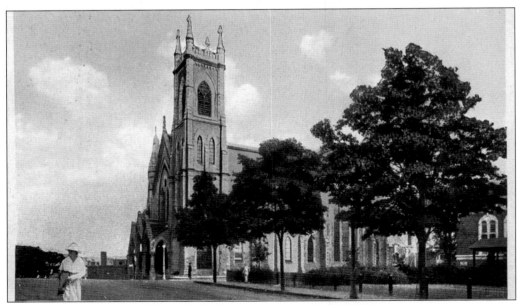

St. Paul's Church, built between 1868 and 1874, was designed by Worcester architect Elbridge Boyden and erected on Chatham Street. When the Diocese of Worcester was created in 1950, the Gothic-style stone church was designated as the Cathedral of St. Paul.

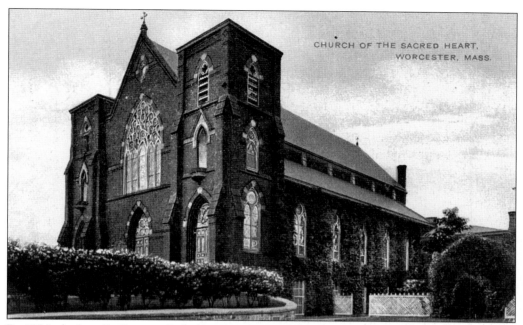

By 1880, the heavily Roman Catholic area of Cambridge Street saw the erection of the Church of the Sacred Heart, the sixth Roman Catholic church in the city. By 1910, this brick Gothic-style church was serving 3,200 area parishioners.

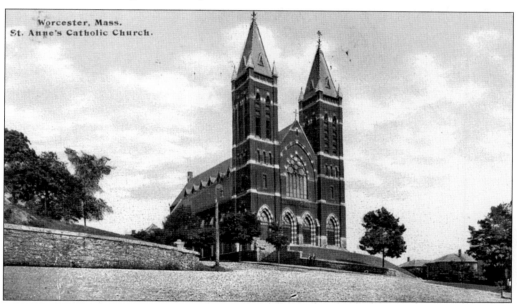

St. Anne's Roman Catholic parish was established as a mission church of St. John's in 1856. A small wooden church was built that year to serve the mostly French-speaking families on the east side. That building was replaced by the brick church in 1867–1868. This view shows the twin towers that rose 135 feet above street level. These spires fell victim to hurricane winds in 1938 and were not replaced. St. Anne's merged with neighboring Our Lady of Mount Carmel parish in 1966, after which St. Anne's was razed.

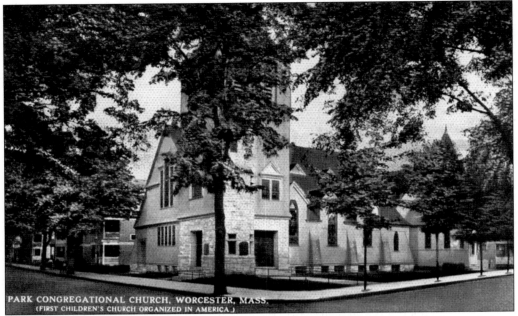

PARK CONGREGATIONAL CHURCH, WORCESTER, MASS.
(FIRST CHILDREN'S CHURCH ORGANIZED IN AMERICA.)

The City Missionary Society decided that a new local church was required to minister to the growing area of Elm Park. In 1886, Park Congregational Church was organized, and the congregation erected the present church, at Elm and Russell Streets, on land given by David Whitcomb. The church is proud of the fact that the first children's church was organized here.

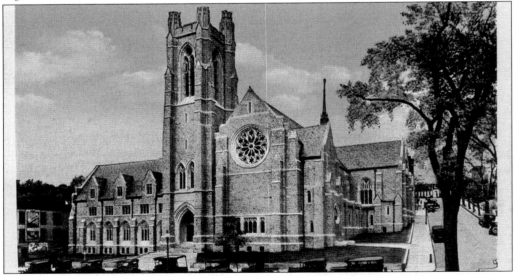

When Wesley Methodist Episcopal Church was erected in 1927 at a cost of $1.1 million, it was stated that the church "was the finest architecturally and educationally in the Methodist denomination." Built of Weymouth granite in the English and French Gothic style by architect H. J. Carlson, it replaced Grace and Trinity Churches. Grace Church member Edwin Brewer gave $100,000 toward the building of the adjacent Brewer Hall. Upon the church's dedication, the congregation numbered 2,560 members.

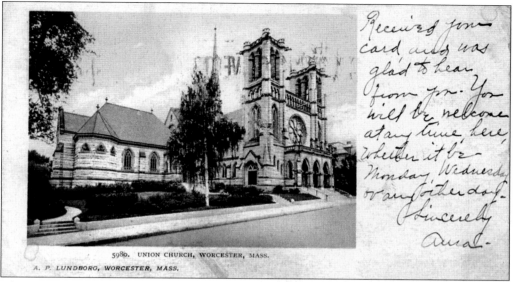

This is an idyllic view of Union Church, now known as Chestnut Street Congregational Church. Perhaps the most elaborate of Worcester's churches, the edifice was designed in the Gothic Revival style by architects Stephen Earle and Clellan Fisher in 1895. Union Congregational Church was organized in 1835 and erected a building on Front Street. Doubled in size, the congregation voted to build a new edifice on Chestnut Street. In 1936, three congregations merged to form Chestnut Street Church. By 1982, Chestnut Street's congregation had united with Central Congregational, closing the Chestnut Street building and joining with Central in its church. Future plans call for the revitalization of this building as a house of worship.

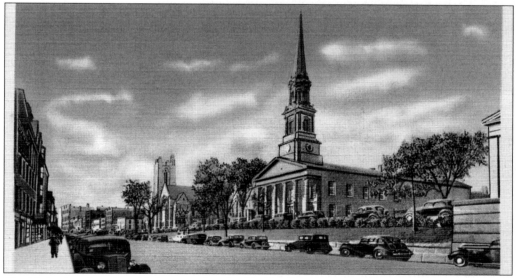

The Unitarian church, with its tower inspired by English architect Christopher Wren, was built in 1851 just south of the courthouse. The building was severely damaged in the 1938 hurricane, and the congregation started work immediately to rebuild it to its original design.

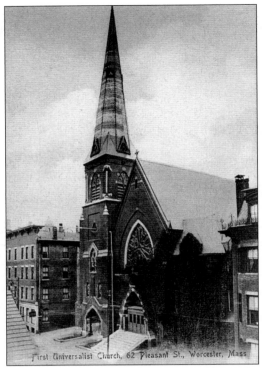

This view shows the First Universalist Church, at 62 Pleasant Street, around 1905. The great theological controversy in the 1820s and 1830s led to the organization of the third religious society in the city. Rev. Lucius Page had preached the doctrine of universal salvation in Worcester by 1834. A religious society was formed in 1841, and a church was built a few years later on the corner of Foster and Main Streets. This was replaced in 1870 by the church seen here. In 1955, the church was sold and a new church was built on Holden Street.

First Universalist Church, 62 Pleasant St., Worcester, Mass

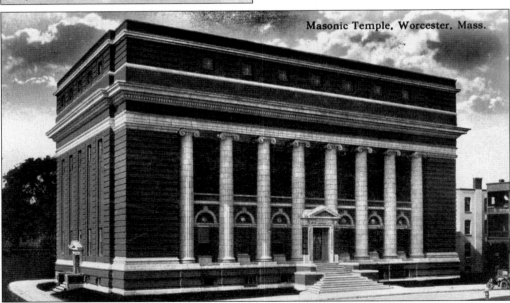

Masonic Temple, Worcester, Mass.

The fraternal brotherhood called the Masons is an ancient order whose members have included George Washington and many other U.S. presidents. The order was introduced into Worcester in 1793, when Isaiah Thomas established a lodge. As their membership grew, the Masons decided to erect a new and larger meeting place. Land was purchased in 1910 on what became known as Ionic Avenue, and this imposing Classical Revival structure was built from the plans of George Halcott.

In 1854, some 53 acres of land were set aside for burial purposes by the city of Worcester, and the burial ground was given the name Hope Cemetery. Soon, more acreage was added, bringing the total to the present 145 acres. In the cemetery, several elaborate memorials were erected by Worcester's leading families. The Romanesque chapel, seen in this postcard, was erected by longtime cemetery superintendent Albert Curtis at his own expense. The chapel was a quiet and reflective spot for mourners for many years, but it gradually fell into disrepair. The costs for repair were prohibitive, and the structure was torn down by the city in 1961.

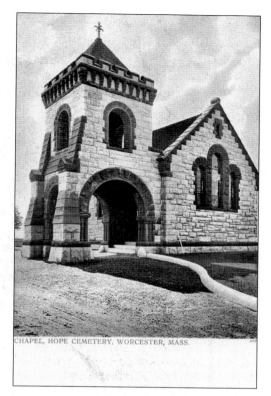

CHAPEL, HOPE CEMETERY, WORCESTER, MASS.

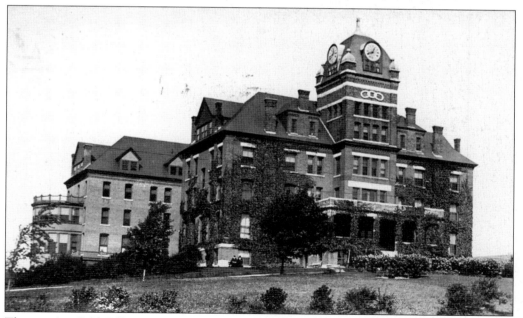

The massive Odd Fellows Home was built in 1892 on Barber Avenue, in the city's Greendale section, on land donated by inventor and attorney Thomas Dodge. The home, with its large addition, continues to provide care for members and others.

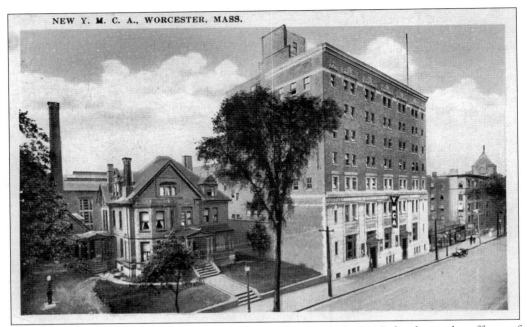

NEW Y. M. C. A., WORCESTER, MASS.

Worcester's first YMCA building was built on Elm Street in 1883 thanks to the efforts of Frederick Clapp and seven clergymen who joined together and decided that Worcester needed a facility for Christian outreach to single young men. In 1915, the original facility was sold and this building was erected on Main Street. Much of this building was demolished in a great expansion of the YMCA in 1983.

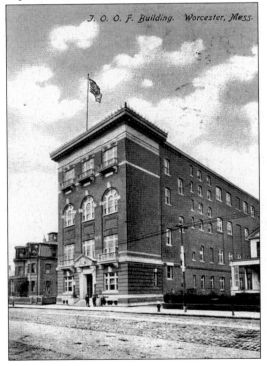

J. O. O. F. Building. Worcester, Mass.

Prior to the creation of the social programs of the 20th century, fraternal organizations were formed to provide members with financial support and fellowship. Among these was the Independent Order of Odd Fellows (IOOF), first organized in the city in 1844. By the end of the 19th century, there were six lodges in Worcester. The IOOF's meeting place on Main Street, seen here, was built in the Beaux Arts style in 1906 by E. J. Cross from the plans of architect Clellan Fisher.

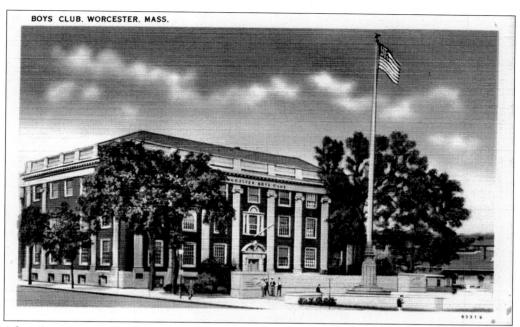

After the relocation of the early Salisbury Mansion at Lincoln Square, the second Worcester Boys Club was built in 1928-1930 from plans by the architectural firm of Frost, Chamberlain, and Edwards. Today, the building is used by Worcester Voke.

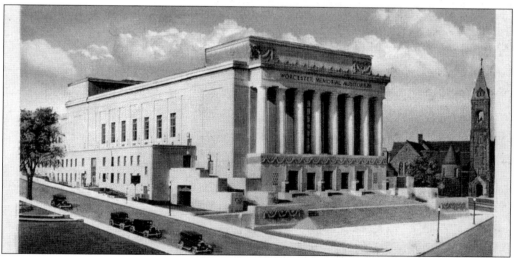

Amid great fanfare, the Worcester Memorial Auditorium opened in September 1933 as a shrine to those residents who lost their lives in war. Lucius Briggs and Frederic Hirons designed this building in what was formerly the Salisbury family orchard. The brainchild of Mayor Pehr Holmes, the building was over a decade in the making. "The Municipal Memorial Auditorium," stated the dedication booklet, "stands in simple grandeur, an enduring tribute to those whose sacrifice was sublime, a majestic memorial for the use and benefit of many generations." Despite these words, the Aud, as it is now called, remains largely vacant, with the exception of the district juvenile court housed in the basement. Its unique organ, one of the largest in the country, with over 6,000 pipes, was walled in during renovations.

The entrance to the Worcester Home Farm, or Worcester Poor Farm, was located on Lincoln Street near Plantation Street. A home for the city's indigent was advocated as early as 1757. Until 1817, the support of the poor, infirm, and aged was auctioned off to the lowest bidder. That year, the Jennison farm was purchased to provide care for these citizens. When the city was established in 1848, an almshouse, a hospital, and 240 acres were acquired. The farm produced milk and vegetables for the city, and the piggery consumed the garbage collected in the city. With the advent of Social Security and welfare, the need for the poor farm diminished, and the establishment closed.

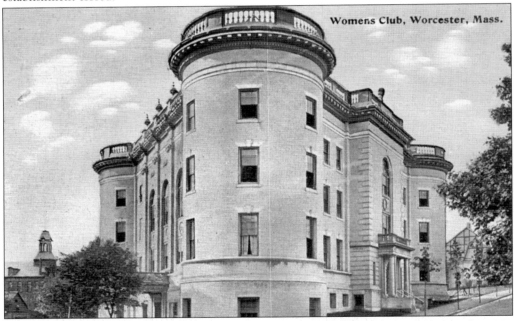

Tuckerman Hall, the clubhouse of the Worcester Women's Club, was newly built when this 1907 postcard was published. Club members approached Stephen Salisbury III and asked to purchase a piece of his property as a location for their clubhouse. He responded by giving them a parcel of his orchard at Wheaton Square on the condition that the building be named in honor of his grandmother Elizabeth Tuckerman. Fitchburg native Josephine Wright Chapman, one of the first woman architects, cleverly designed the building to fit the small triangular lot. Maintenance costs required that the building be sold in 1971. The following year, the Central Massachusetts Symphony Orchestra leased the building, and the group purchased it in 1981. An extensive restoration, costing $1.7 million, was completed in 1999.

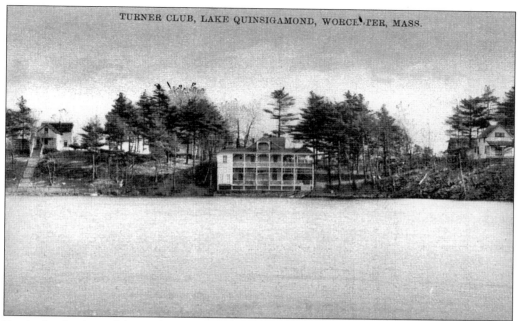

By the beginning of the 20th century, Lake Quinsigamond had grown into the area's prime recreational destination. As a result, numerous groups established summer quarters along the shoreline. This *c.* 1915 postcard shows a view of the Turner Club (Turn Verein), organized by the area's German-American community. The site currently houses the Lithuanian War Veterans Society.

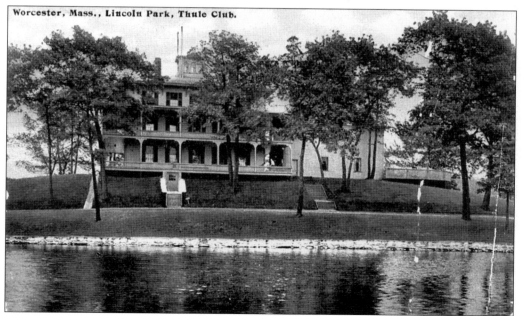

Worcester, Mass., Lincoln Park, Thule Club.

The Thule Club, of which little is known, had its quarters near Lincoln Park on the Worcester shoreline and appears to have been one of the numerous Swedish-American clubhouses that were constructed at the lake. The club is seen here in 1910.

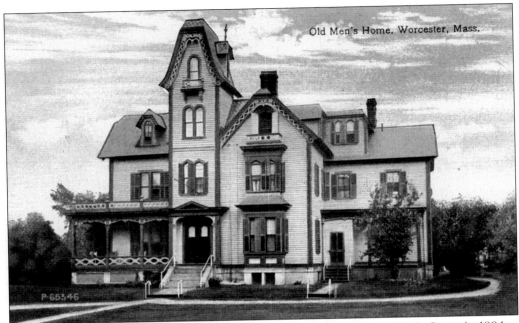

Old Men's Home, Worcester, Mass.

Judge Harry Chapin and businessman Albert Curtis bought property on Main Street in 1884 to establish the Old Men's Home. The facility, housed in this wooden Victorian structure, opened in 1891. With a bequest of Harry W. G. Goddard in 1919, a new brick building was constructed and was named Goddard House.

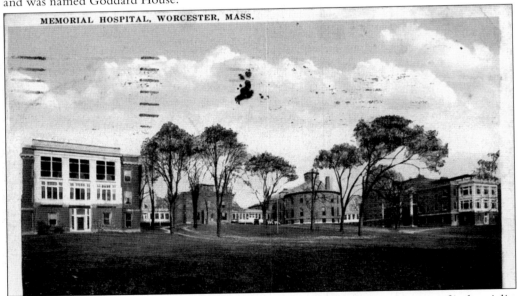

MEMORIAL HOSPITAL, WORCESTER, MASS.

Memorial Hospital, originally named Washburn Memorial Hospital in memory of industrialist Ichabod Washburn's two daughters, opened in 1885 in the Samuel Davis mansion on Belmont Street, seen on the left. At first, only women and children were treated at Memorial. The circular Moen Building was added in 1892 with the support of Phillip Moen, an associate of Washburn. These buildings were later demolished to make way for a new ward. Memorial Hospital merged with UMass Medical Center in 1998 and is now called UMass Memorial Healthcare.

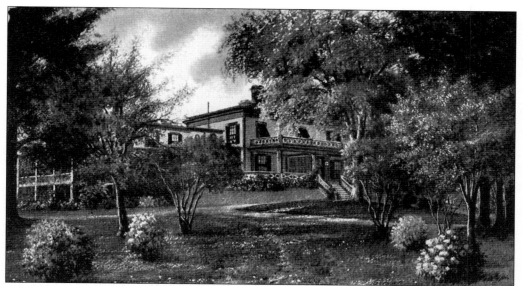

Hebert Hall, located at 223 Salisbury Street, was another privately operated institution. Well into the 1930s, this hospital housed patients with "mental and nervous diseases."

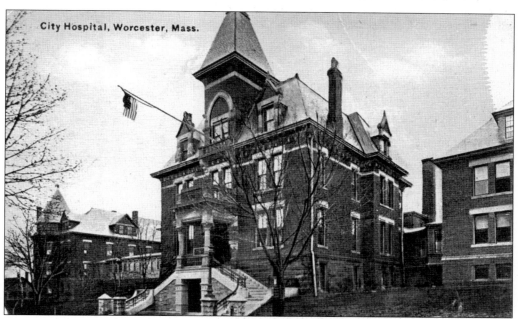

Worcester philanthropist George Jacques donated $200,000 to the city for the founding of a hospital. In a time when few could receive medical treatment, Jacques's gift made possible the opening in 1871 of City Hospital in the former Abijah Bigelow House, at Front and Church Streets. In 1881, the hospital moved into a new building on three-and-a-half acres of the former Jacques residence at Chandler and Wellington Streets. The Knowles Maternity Ward, a gift of Helen C. Knowles, opened shortly afterward. The Gill and Salisbury Wards were added next, the gifts of Sarah Gill and Stephen Salisbury III. Shown are, from left to right, the Knowles Maternity Ward, the 1881 Jacques Administration Building, and the Gill Ward.

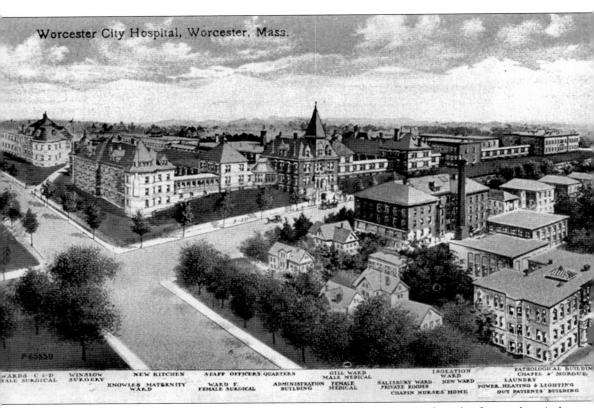

Worcester City Hospital, Worcester, Mass.

P 65359

WARDS C &-D WINSLOW NEW KITCHEN STAFF OFFICERS QUARTERS GILL WARD ISOLATION PATHOLOGICAL BUILDIN
ALE SURGICAL SURGERY MALE MEDICAL WARD CHAPEL & MORGUE
 KNOWLES MATERNITY WARD F. ADMINISTRATION FEMALE SALISBURY WARD NEW WARD LAUNDRY
 WARD FEMALE SURGICAL BUILDING MEDICAL PRIVATE ROOMS POWER, HEATING & LIGHTING
 CHAPIN NURSES' HOME OUT PATIENTS' BUILDING

This bird's-eye view shows the sprawling City Hospital *c.* 1910. Today, the former hospital
buildings house a variety of services, including a clinic and an addiction center.

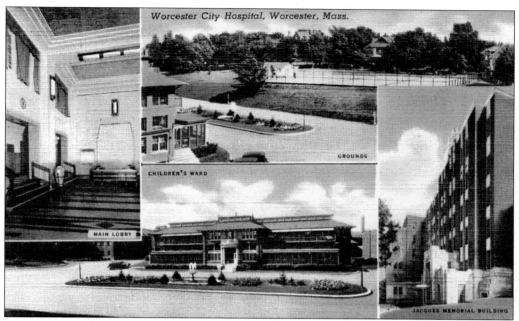

This 1942 postcard features impressive views of City Hospital. As one can see, the complex at one time featured manicured grounds and well-maintained buildings, which created a soothing atmosphere for those staying within the confines of the institution. For generations, the municipally operated hospital provided quality care to those in need.

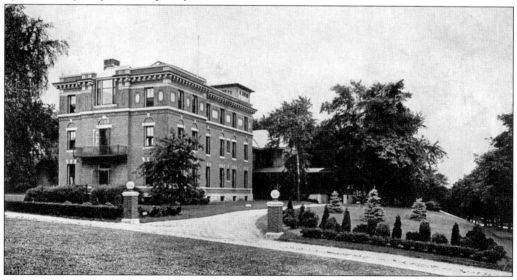

Hahnemann Hospital was Worcester's osteopathic hospital. The theory of treating patients with minor doses of medicines and manipulation of the bones and muscles was originated by German doctor Samuel C. F. Hahnemann. In 1896, Hahnemann Hospital was opened on Providence Street, and in 1904, it was moved to a house on Lincoln Street, seen in this view. This 35-bed hospital was joined with a separate addition in 1926, financed in part by a $25,000 bequest from David Hale Fanning. In 1994, Hahnemann closed as an acute hospital and became an outpatient center. The hospital later reopened as a campus of Central Massachusetts Health Care.

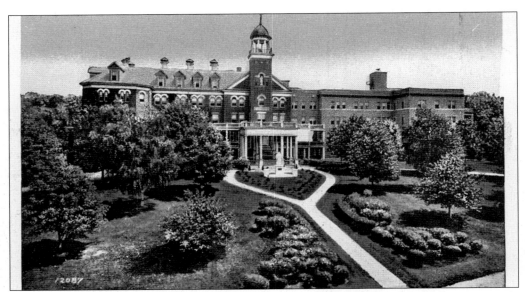

Shortly before 1895, the Sisters of Providence were asked by the pastor of St. John's Church, Rev. Thomas Griffin, to come to the city and open a hospital on the recently purchased Bartlett farm on Providence Street. St. Vincent's Hospital grew from that 12-bed hospital to the 150-bed brick hospital seen in this view and then to a 600-bed hospital in 1954, becoming one of the leading hospitals in the city. Today, St. Vincent's Hospital is located in the Worcester Medical Center (Med City). This building was demolished in 1973.

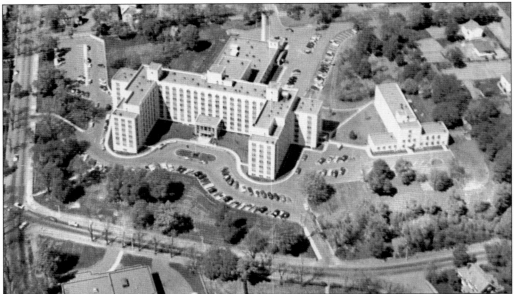

St. Vincent's Hospital, located at the corner of Winthrop and Vernon Streets, was overseen by the Sisters of Providence. A state-of-the-art facility was dedicated in March 1954 at Winthrop and Providence Streets. The hospital was constructed on the grounds of the former Crompton estate. This early view shows the medical facility at the center and the convent at the right. The completion of Med City in downtown Worcester resulted in the transfer of this hospital to new quarters. Currently, this complex stands vacant.

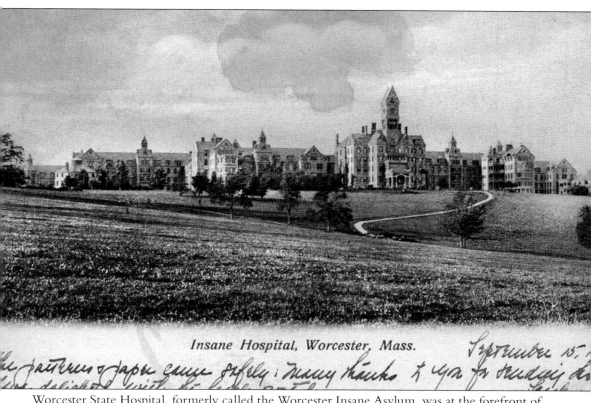

Insane Hospital, Worcester, Mass.

Worcester State Hospital, formerly called the Worcester Insane Asylum, was at the forefront of mental illness treatment. The original facility was built on Summer Street between 1874 and 1879. A larger stone complex, seen here, was designed by the architectural firm of Weston & Rand and built in the farmland west of Lake Quinsigamond. Stone from the adjacent quarries at Millstone Hill was used to construct the four-and-a-half-story building, which stretched over 1,000 feet after additions were made in 1887. The Gothic style of the buildings, with the central clock tower rising above them, evokes a sense of foreboding. Several of the vacant buildings were destroyed by fire in 1991. For many years, a large dairy farm was part of the hospital's program. The hay fields and stone walls stretching to the lake created a rural scene for visitors entering the city from the east. New mental health facilities have been constructed on part of the property, and the UMass Medical Hospital and commercial structures fill the fields.

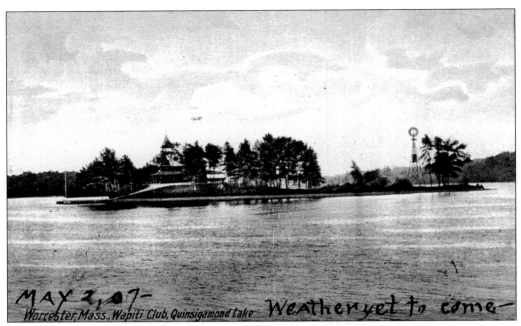

This postcard, dated May 2, 1907, shows a distant view of the Wapiti Club. The site was later home to the Algonquin Canoe Club. It is now a private residence.

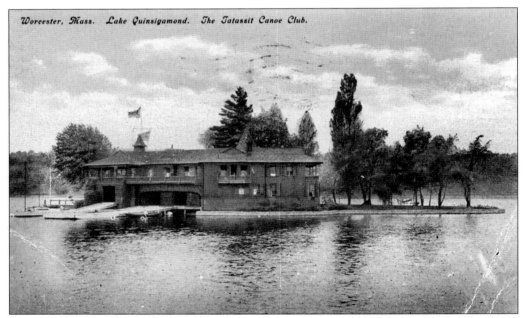

This 1910 postcard shows the Tatassit Club, one of the numerous social, athletic, and boat clubs that are part of the storied history of Lake Quinsigamond. The first, Turner Club (Turn Verein), began in 1870 and led to the establishment of a large number of other such clubs.

Six

GREEN SPACES

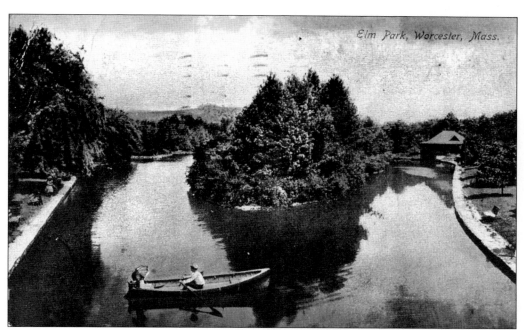

Elm Park, also known as the New Common, was purchased by the city in 1854, becoming the first tract of land set aside for a park. The original 28-acre site hosted circuses, cattle shows, and other events. Under the direction of Worcester Shade Tree and Public Parks director Edward Lincoln, the 60 acres of adjacent Newton Hill were added to the park, and a program of landscaping and improvement was begun. With a bequest of $1,000 from former mayor Levi Lincoln, extensive plantings and the erection of two picturesque bridges made Elm Park a popular and delightful space for residents.

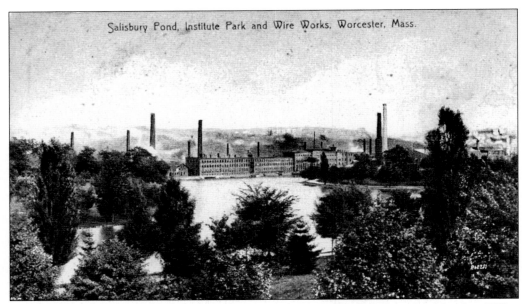

Salisbury Pond, Institute Park and Wire Works, Worcester, Mass.

This bird's-eye view shows Salisbury Pond and the north works of the American Steel and Wire Company. The company, which began as the Washburn and Moen Wire Works in 1846, had by 1895 become the world's largest producer of wire products. The company was the city's largest employer when it became American Steel and Wire in 1899. In order to fill its labor needs, the company became a major player in encouraging European immigration to the city.

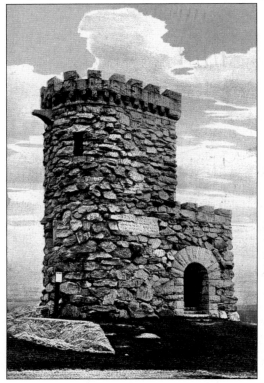

In 1884, Worcester became the recipient of Lake Park through the generosity of Edward L. Davis and Horace H. Bigelow. Davis had his namesake stone observation tower constructed in the park to provide a panoramic view of Lake Quinsigamond. A 1911 Worcester Parks Commission report noted that the tower had been fitted with iron gates, "as it was found necessary to regulate the hours of admission, owing to its misuse by a few thoughtless persons." The tower has since been demolished.

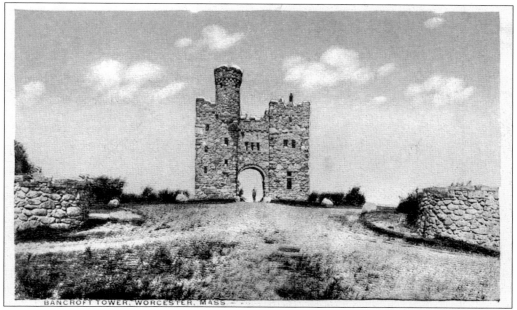

In 1900, on the high hill south of the site of George Bancroft's home, Stephen Salisbury III built a rustic stone tower in memory of his father's friendship with George Bancroft. Born in Worcester in 1800, Bancroft was a prominent statesman, politician, and horticulturist. Known as "the Father of the Navy," Bancroft established the Naval Academy at Annapolis, authored the *History of the United States*, and gave the eulogy for Abraham Lincoln.

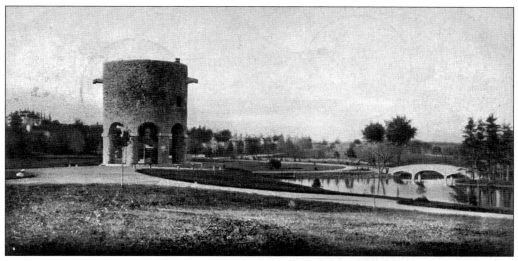

Stephen Salisbury III, Worcester's greatest philanthropist, donated 17 acres of pastureland on Salisbury Street in 1887, and Institute Park was created there under his direction. At a personal cost of over $50,000, Salisbury built a boathouse, shelters, a bridge spanning Salisbury Pond, and a copy of the Viking tower, or stone mill, that stands at Newport, Rhode Island. While in Boston, Salisbury observed the razing of the Tremont House hotel, with its monolithic granite pillars. He purchased two of the columns, moved them to Worcester, and erected them in his park. The boathouse and the Norse tower were torn down by the city after many years of neglect.

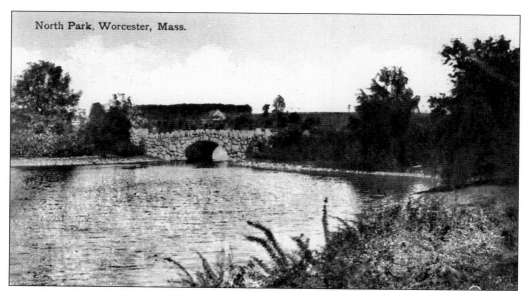

North Park, Worcester, Mass.

During Worcester's flurry of acquisition of parklands in the 1880s, a park was proposed for the city's north end. The land for North Park was purchased in 1888, and work was begun on improvements, including the raising of the mere, or pond, on the property. Grading and landscaping was done, and a rustic bridge was constructed. The park was severely impacted by the construction of Waweckas Road School on parkland and by the building of Interstate 290 through the park in the 1960s.

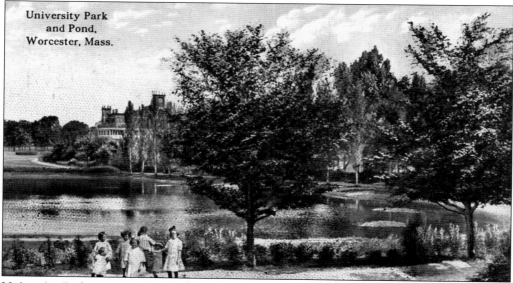

University Park
and Pond,
Worcester, Mass.

University Park was purchased by the city for $80,000 in 1887–1888 in conjunction with the founding of adjacent Clark University. It proved a popular spot for neighbors in the south Main Street area and was intended to "provide youth who may be expected to throng the courts of Clark University with a much needed playground." A wading pool and fountains were opened in 1911. The name later reverted to Crystal Park, after adjacent Crystal Street. That street and nearby Illinois Street were named by one of the former landowners after his home in Crystal Lake, Illinois. In the background, the first building of Clark University can be seen.

The Green family mansion was constructed in 1757 by Dr. John Green and was enlarged to 42 rooms by Andrew Haskell Green. Following the conveyance of the estate to the city in 1905, the mansion became city property, and for several years, it was rented for events and dances. The mansion was later deemed too expensive to maintain, and after several years of controversy, it was demolished by the city in 1957. Wrote preservationist Mary Rochette Bundeff in 1954, "Yes, tear it down . . . but let us all know what we are discarding so ruthlessly."

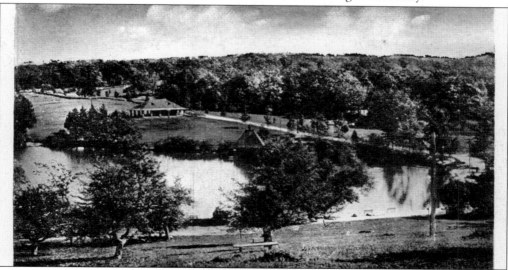

During Martin Green's ownership of the mansion, the grounds were landscaped under the influence of America's first landscape architect, Frederick Law Olmsted. In 1881, a dam was built across Hermitage Brook, creating a 60-acre pond. The refectory by the pond was built in 1911. Andrew Green died in 1903, and his five nephews and nieces, Samuel, William, Lucy, Mary, and Nathaniel, transferred the 500-acre estate to the city in 1905. The grounds and mansion suffered long periods of neglect until the mansion was finally torn down in 1957. In recent years, the park has seen a rebirth, with the erection of the state Vietnam Veterans Memorial on the property.

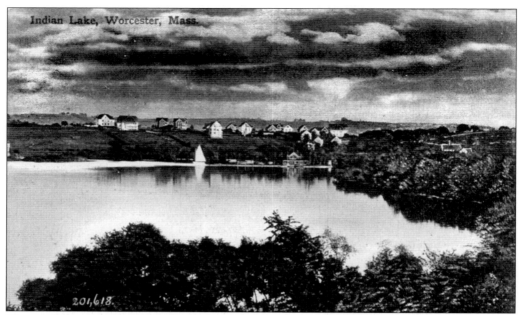

The scenic beauty of North Pond, renamed Indian Lake, is seen in this *c.* 1905 postcard. Area residents enjoyed boating and swimming, and summer cottages sprang up along the shore, especially on Sears Island. The lake is still a popular summer destination, with a park, boating area, and beach located on its shores.

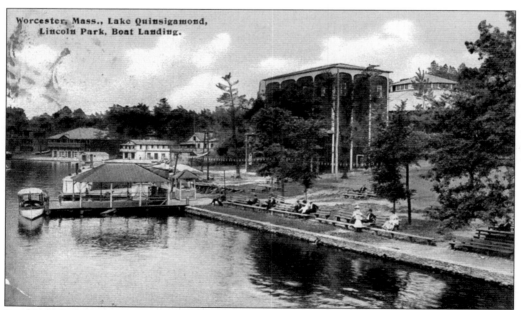

Developed over a period of years by entrepreneur J. J. Coburn, Lincoln Park was the first amusement center at Lake Quinsigamond. Eventually, a dance hall, bandstand, carousel, and theater (seen here at the center) were added. Today, the site houses two high-rise apartment buildings for the elderly.

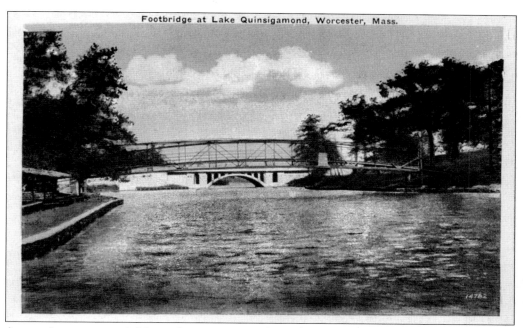

At one time, many activities and events occurred at Lake Quinsigamond. The small island just south of the bridge contained a hotel and a picnic grove. It was connected to the west shore by this footbridge to Lincoln Park.

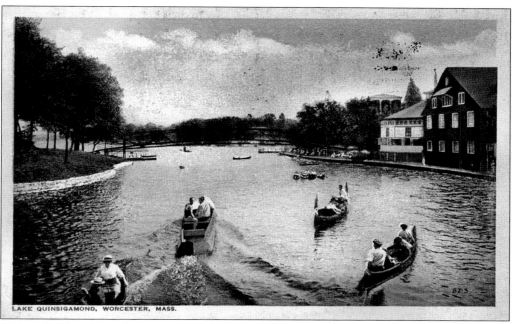

LAKE QUINSIGAMOND, WORCESTER, MASS.

Although Lincoln Park was never as large as its counterpart, White City, it was more of a recreational area, where residents could picnic and enjoy a summer's day boating on the lake.

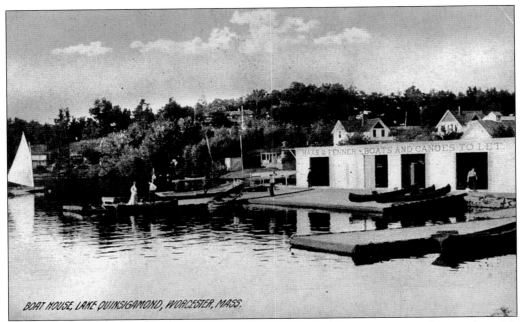

Boat and canoe rentals were available at Lincoln Park and proved immensely popular with visitors. This *c.* 1915 postcard features the Haas & Fenner rental business. Lake Quinsigamond continues to be a popular local spot for recreational boating and canoeing.

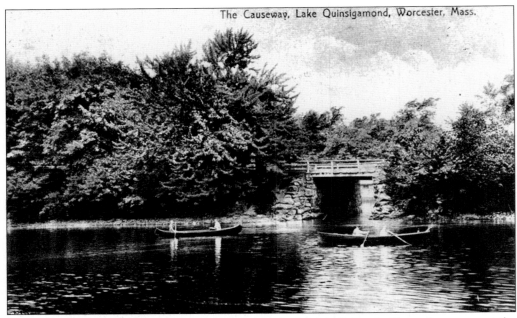

The ancient crossing of the Boston Post Road, today's Main Street in Shrewsbury, was at the northern end of Lake Quinsigamond. This crossing was the only bridge across the lake until the Boston & Worcester Turnpike opened in the early 19th century.

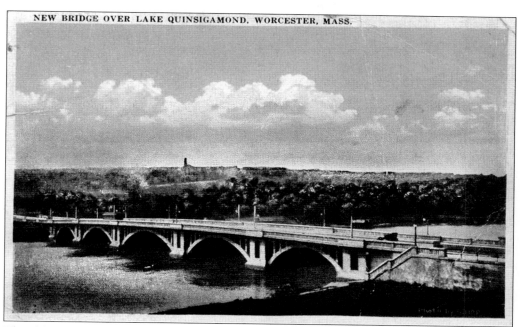

The old earthen causeway proved impractical and unsightly. After half a century, a new concrete bridge was planned, and construction began in 1916. After a short delay due to World War I, the new Lake Quinsigamond Bridge was completed in 1919.

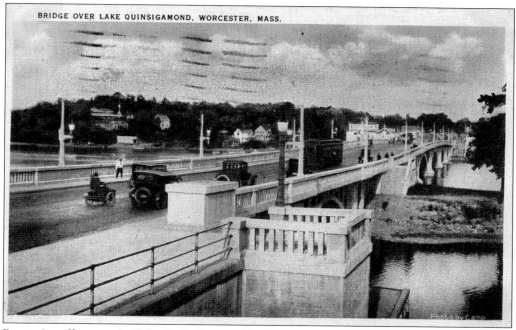

Route 9 traffic over the Lake Quinsigamond bridge appears to be much lighter than today's in this 1937 postcard view, which shows car, motorcycle, and trolley traffic.

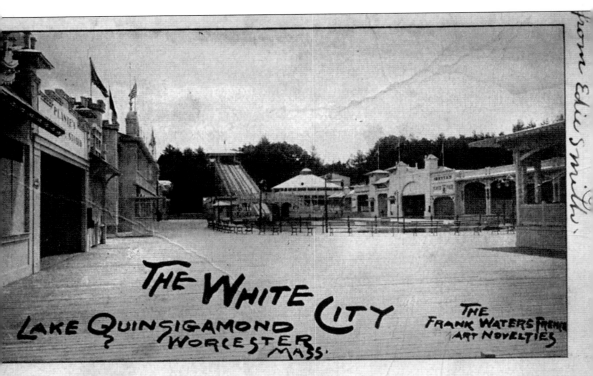

THE WHITE CITY
LAKE QUINSIGAMOND WORCESTER, MASS.

THE FRANK WATERS FRENCH ART NOVELTIES

Horace Bigelow, a master in the art of entertainment, opened his White City amusement park in the summer of 1905. The venue was an instant sensation with the local population and remained popular for generations. The park was home to many rides, such as the Gee Wiz and Zip roller coasters, and to a boardwalk and fun house. This rare postcard features a general view of the park grounds.

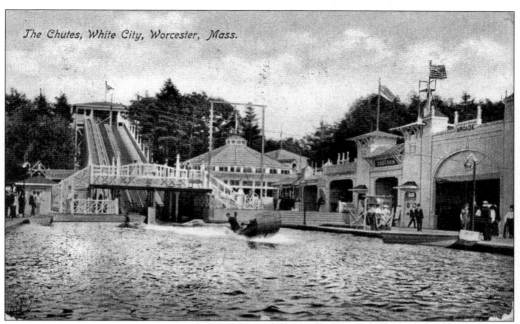

The Chutes, White City, Worcester, Mass.

Shoot-the-Chutes was an early version of today's flume rides and a featured attraction at White City. Boats were pulled up the chute and released, sending happy riders down the slope and into the pool. On a hot summer's day, the expected soaking must have been a relief.

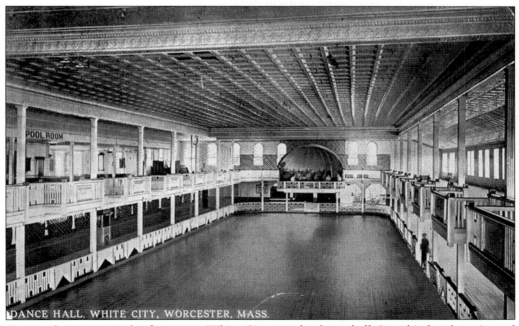

DANCE HALL, WHITE CITY, WORCESTER, MASS.

Among the more popular features at White City was the dance hall. Jazz, big band music, and the rock and roll craze kept generations of area residents glued to the dance floor. The hall survived a disastrous 1939 fire to remain the park's foremost attraction.

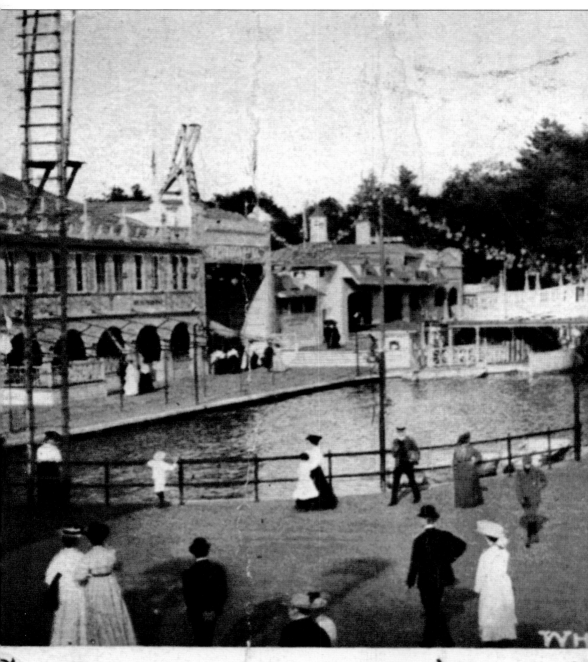

Visitors to the park stroll along the boardwalk in this 1906 view of White City. The Foolish House was located at the right; this early version of the fun house was overseen by King Dodo, a large statue located outside the entrance. In the center are the pool and the popular chute ride.

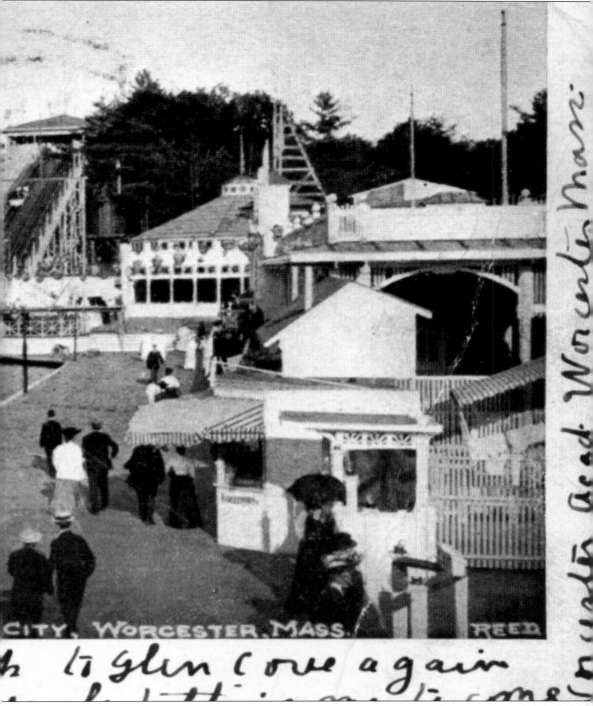

In addition, the park featured a roller coaster, an airship ride, and numerous other attractions and oddities.

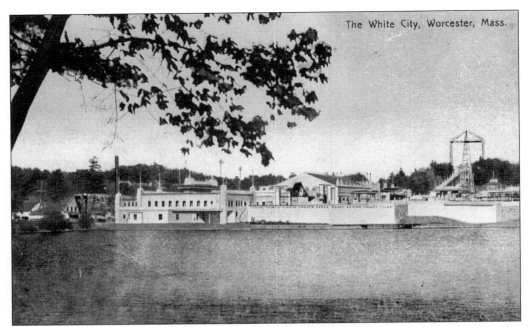

White City amusement park is seen from the Worcester shoreline of Lake Quinsigamond in this 1908 postcard view. Constructed on the Shrewsbury side of the lake, the park remained an area attraction until 1960. The site is now occupied by the White City shopping complex.

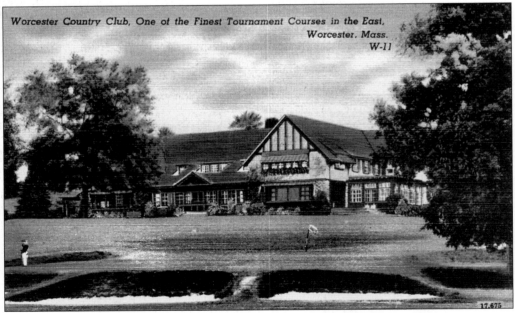

The Worcester Country Club is located on 210 acres of the former Calvin Rice Farm off Mountain Street East. The club, the successor to the Worcester Golf Club, was formed in 1900. The 1914 clubhouse was designed by Lucien Briggs in the Georgian style, and the course was laid out by renowned golf course architect Donald Ross. Former president William Howard Taft was the guest of honor at the opening and drove the first ball on the links.

Seven

INSTITUTIONS FOR LEARNING

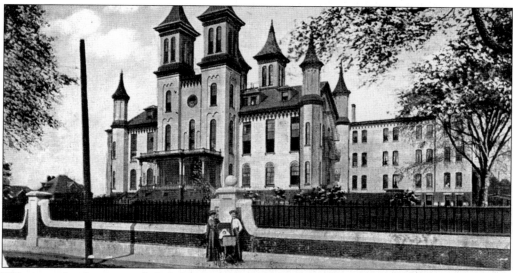

Worcester Academy was founded in 1834 by a number of Worcester industrialists, including Ichabod Washburn, a prime mover in the founding of Worcester Polytechnic Institute. Originally located on Main Street, the Worcester County Manual Labor High School became Worcester Academy in 1869. That year, the school moved to its present campus on Union Hill. The academy moved into the 1852 Davis Hall, the turreted Gothic building shown, which formerly had been the Dale Hospital for Civil War soldiers. Designed by noted Worcester architect Elbridge Boyden, Davis Hall was torn down in 1964. Women were admitted from 1869 to 1890, after which the academy admitted only men. Policy was changed in 1972 to again allow admittance to women. The academy grew over the years, adding buildings to the expanding campus.

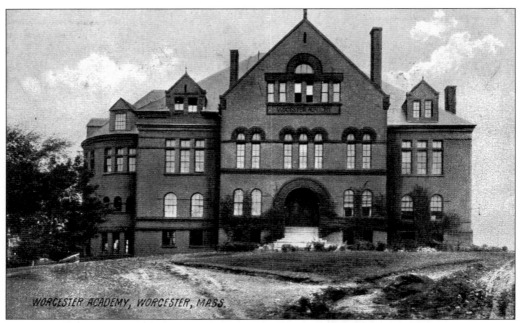

Walker Hall, pictured on this postcard, was added to the campus in 1889, followed in 1892 by Dexter Hall, a gift of Charlton businessman William H. Dexter.

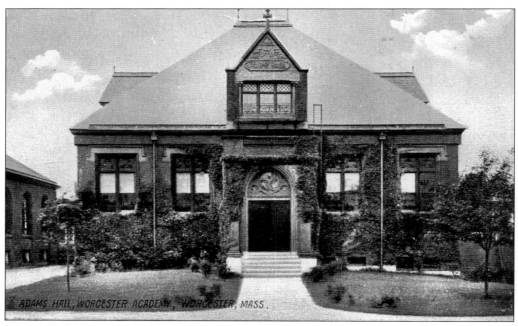

Adams Hall, pictured on this card, was constructed in 1892. The academy has continued to expand, and today, the campus encompasses a number of sites, including an athletic complex on Stafford Street.

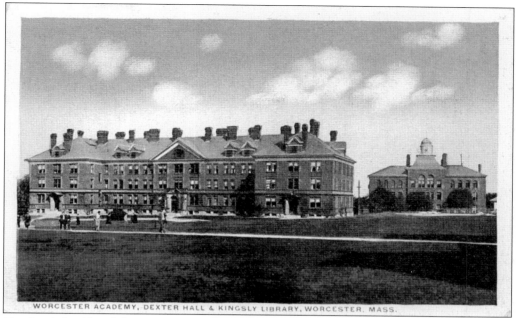

WORCESTER ACADEMY, DEXTER HALL & KINGSLY LIBRARY, WORCESTER, MASS.

On the right side of the postcard is Kingsly Laboratories (not the library, as the card states), which opened in 1897, just six years after the trustees voted to return to an all-male student body. Women had been admitted since 1856, but after the policy was changed in 1890–1891, they were not admitted again until 1974.

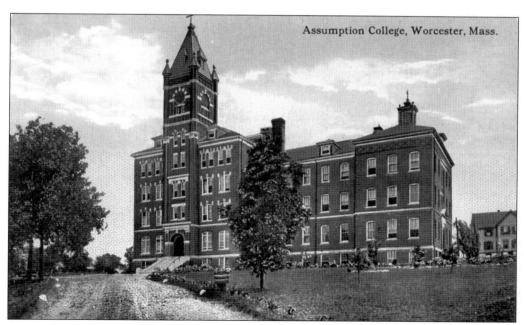

Assumption College, Worcester, Mass.

Assumption College was founded in 1904 by the Roman Catholic Augustinians of the Assumption to provide a French-language institute of higher learning. In its early years, the college concentrated on preparing young Franco-Americans for the priesthood.

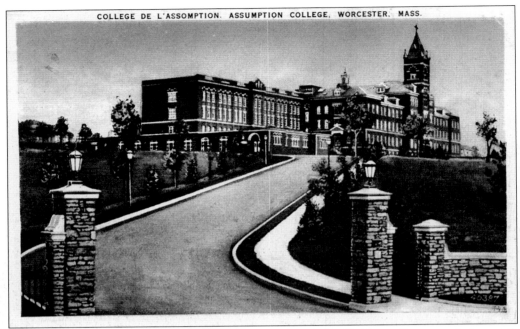

COLLEGE DE L'ASSOMPTION. ASSUMPTION COLLEGE, WORCESTER, MASS.

The central part of this building was constructed on West Boylston Street, and the south wing, seen in this 1920s postcard view, was added in 1912. The north wing was constructed by A. O. Nault in 1922. The 1953 tornado severely damaged the building, leaving three people dead.

The college decided on a new location on Salisbury Street following the tornado of 1953. The old campus building was repaired and is now the main building of Quinsigamond Community College.

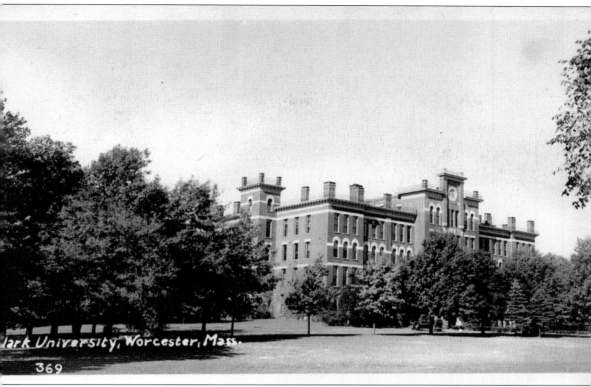

Clark University, Worcester, Mass.

369

Clark University opened as a graduate school in 1887 to fulfill the plans of Hubbardston native Jonas G. Clark to establish a place of higher learning that allowed time for research and study, as well as academic work. On eight acres in the south end of Worcester, Clark erected this four-story building, which was designed to function as a mill if his plans for the university could not be fulfilled. This rare postcard view shows a scene vastly different from that of today.

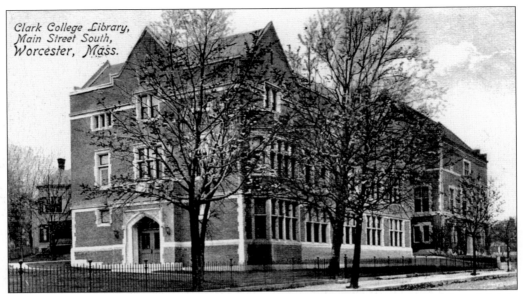

The campus has expanded significantly over the years to encompass a large area of south Main Street. Today's Crystal Park was set aside by the city at the time of the university's founding and was named University Park. The Clark University library building, seen here, was erected in 1901 and was the third building on campus. A library fund of $100,000 was established by college founder Jonas Clark, and the firm of Frost, Briggs, and Chamberlain was commissioned to build the library.

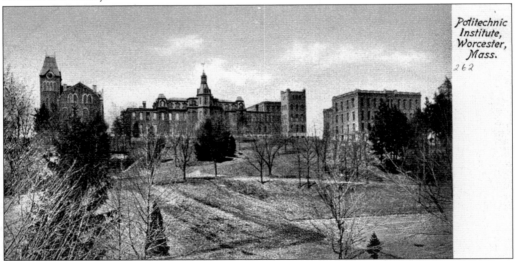

In 1864, John Boynton gave $100,000 as an endowment to establish a "free school or institute to benefit the youth of the county." To this was added $50,000 from Ichabod Washburn for the establishment of a machine shop and a mechanical department at the institute. In addition to a bequest, Stephen Salisbury gave acreage on which to build the school. The stone, mansard-roofed Boynton Hall, seen on the left in this photograph, was dedicated in 1868. The goal of the institute was to provide its students with sufficient mechanical knowledge for them to successfully engage in industrial and engineering processes. The Washburn machine shop and the Salisbury Laboratory were soon built, followed by an electrical engineering shop.

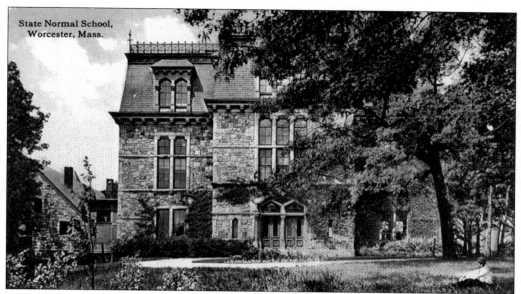

State Normal School,
Worcester, Mass.

The forerunner of Worcester State College was the Worcester Normal School, established in 1871 for the training of men and women for teaching positions in the state's schools. This stone, mansard-roofed building was located on five acres of land known as St. Anne's Hill, which was originally part of the grounds of the Worcester Lunatic Hospital. During the 25 years of supervision of its first principal, E. Harlow Russell, the school saw a rapid growth in enrollment. The overcrowded school closed in 1932 and moved into spacious new quarters on Chandler Street, which are now part of Worcester State College. In 1943, a portion of the old vacant building collapsed and the remainder was razed. The land remained vacant for many years until City View School was built on the site.

By the early 1930s, a new Worcester State Teachers College had been constructed on Chandler Street. Enlarged over the ensuing decades and renamed Worcester State College, the institution has expanded its educational boundaries while maintaining its original mission of training tomorrow's teachers.

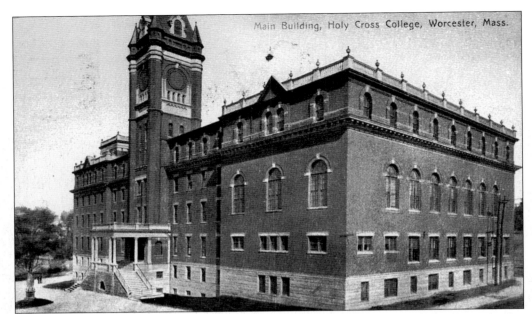

The College of the Holy Cross had its beginnings in 1842, when the Rev. James Fitton built a small seminary on the side of Pachachoag Hill near the Auburn town line. In that year, Bishop Fenwick of Boston, who had prayed for a new Catholic school, accepted Reverend Fitton's gift of the seminary and 60 acres of land. The large brick structure, shown here, was built but was soon severely damaged by fire. Classes were suspended until the building could be rebuilt. The school reopened in 1853.

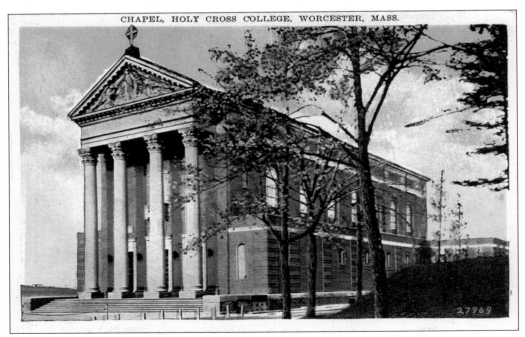

This is a *c.* 1920 view of St. Joseph's Memorial Chapel at Holy Cross.

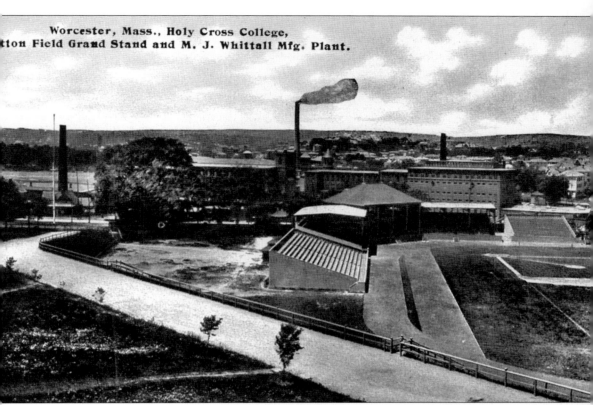

Fitton Athletic Field, seen in this view, was erected below the College of the Holy Cross in 1924 and was named for Rev. James Fitton. Greatly expanded, the college continues to play a major role in Worcester's college life. Fitton Field has undergone expansion to become the home of the Worcester Tornadoes of the Canadian–American baseball league.

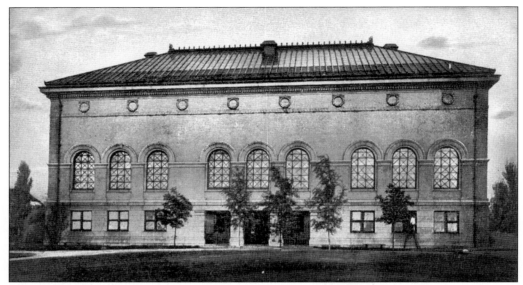

The Worcester Art Museum has been called one of America's prominent art museums for a city of this size. The foundation of the museum can be credited to the Salisbury family, the city's great benefactors. Steven Salisbury III gave the land and an endowment to benefit the museum before his death. Designed by Stephen C. Earle and built by E. J. Cross on Salisbury Street in 1898, the museum has been expanded and remodeled many times. This postcard view is from 1905.

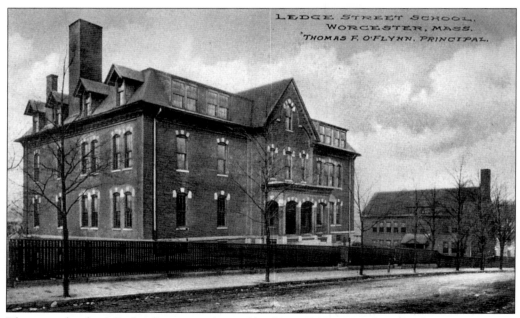

The two schools on Ledge Street are pictured in this *c.* 1915 postcard. In the foreground stands Schoolhouse No. 1, which opened in September 1870. It was demolished in 1954 to provide for more playground space for Schoolhouse No. 2, seen in the distance. Schoolhouse No. 2 opened in May 1887 and was enlarged in 1910. The construction of Interstate 290 doomed the second school; it was closed in September 1958 and demolished shortly thereafter.

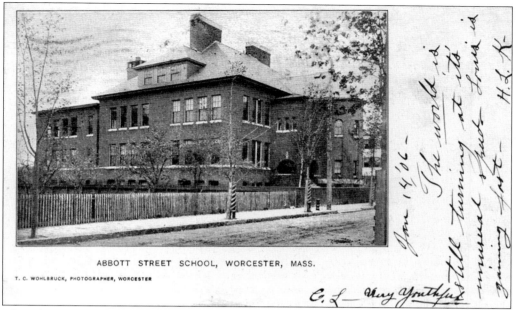

ABBOTT STREET SCHOOL, WORCESTER, MASS.

T. C. WOHLBRUCK, PHOTOGRAPHER, WORCESTER

The Abbott Street Schoolhouse, designed by Forbush and Hathaway, was opened in May 1895 and served this section of the city until June 1981. Following its closing, the building was converted into condominiums. This 1906 view shows the schoolhouse shortly after its 1905 enlargement.

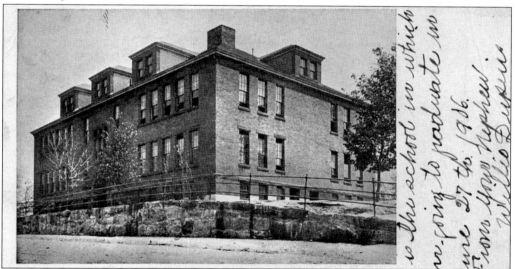

With this card, May Dupuis of Weymouth was invited to attend the June 1906 graduation of her nephew Willis Dupuis from the Greendale School. First occupied in April 1894, this school was enlarged in 1898 and 1922. The Greendale section of the city must have been quite remote in 1894. Shortly after the school's opening, the superintendent of schools noted that it "is located upon three streets—Francis street, Bradley street and Summit avenue—or what are supposed to be streets at no distant day, but they are difficult of access and will require a considerable expenditure of money and labor to make them passable." The school continues to serve the surrounding neighborhoods.

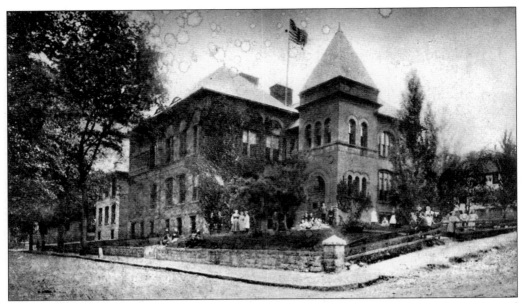

The Elizabeth Street Schoolhouse opened in September 1894 and was enlarged in 1896 and 1925. The school served the Belmont Hill neighborhood until June 1982. Following its closing, the school was converted into condominiums. An advertising brochure for the new apartments stated, "Return to the dignified elegance of the 1890s blended with the modern conveniences of the 1980s."

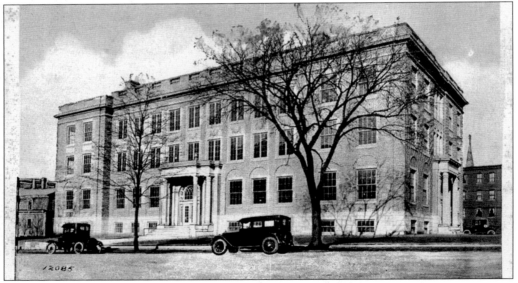

"Crowded conditions have prevailed, and this situation seems inevitable until a larger building is provided," stated a 1915 report on the Trade School for Girls. It took six years and a gift from an industrialist to bring a new school to fruition. David H. Fanning, president of the Royal Worcester Corset Company, donated $100,000 towards the construction of a new building, which was dedicated in December 1921. In honor of his gift, the new school was named the David Hill Fanning Trade School for Girls. The building now houses several school administrative departments.

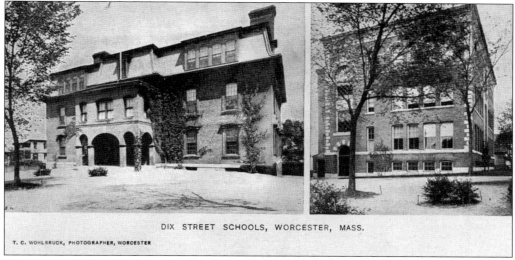

DIX STREET SCHOOLS, WORCESTER, MASS.

This postcard features the two schoolhouses that were located on Dix Street. Schoolhouse No. 1, on the left, opened in 1868, and its counterpart, Schoolhouse No. 2, opened in 1902. As early as 1949, one report stated that both were "bad fire risks" and should be vacated. As if to justify the earlier report, a fast-moving fire destroyed the older building in January 1968, and the school was subsequently demolished. Schoolhouse No. 2 remained open until it was replaced by Elm Park Community School in 1971.

The Grafton Street schoolhouses are pictured on this 1911 postcard. In the foreground stands Schoolhouse No. 1, which opened in 1880 and is currently the oldest operating school building in the city. Schoolhouse No. 2, in the rear, opened in September 1900 and proved a letdown to some officials. One report noted, "The interior arrangements of the building are ideal . . . The exterior of the building is disappointing, and, in the opinion of members of the School Committee who live in the ward, it is a public monument to the folly of a pinching and penny-wise economy."

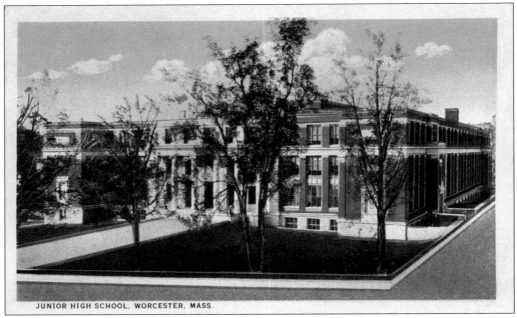

JUNIOR HIGH SCHOOL, WORCESTER, MASS.

The Grafton Street Junior High School was the first of its kind to be constructed in the city. Opened in September 1924, it served as a junior high until it was closed for renovations in January 1969. The school reopened in the fall of 1971 as the Worcester East Middle School.

High School, Worcester. Mass.

South High was the largest high school in the city at the time of its opening in September 1901. The construction of an addition was marred by tragedy when two workers were killed in an accident in October 1930. South High was transferred from this building to the new site off Apricot Street in 1978. This school became Sullivan Middle School. It now houses the Goddard School of Science and Technology.

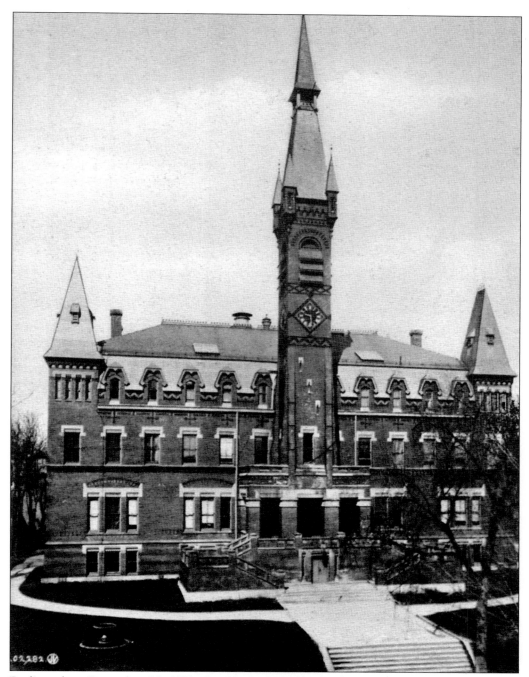

Dedicated on December 30, 1871, the Classical High School on Walnut Street was designed by renowned architect Henry Hobson Richardson. In 1914, the student body was transferred to the former English High School on Chatham Street. This building was then enlarged and reorganized as the High School of Commerce. The opening of Doherty High School necessitated the closing of Commerce High, and the building was demolished in the summer of 1966 to make way for an addition to the Paul Revere Insurance Company.

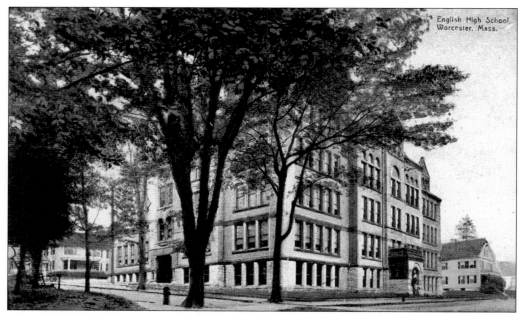

This school has an interesting history. It was opened with much fanfare as the English High School in September 1892. In 1914, English High School was closed, and the building became home to Classical High School, which had been located on Walnut Street. The opening of Doherty High School resulted in the closing of this school in June 1966. The building now houses the administrative offices of the Worcester public schools. The great hurricane of September 1938 severely damaged the structure. After a massive rebuilding, the school reopened in April 1940.

The roots of the Worcester Boys Trade School reach back to a 1906 meeting of individuals interested in vocational training. Four years later, on February 8, 1910, the new school was dedicated. Enlarged over the years, the current "Worcester Voke" will be replaced with a new facility, which is currently under construction. Its successor will adhere to the same goals put forth in 1910: to make students "feel a sense of responsibility as workmen and contributors to the welfare of the State and Nation."

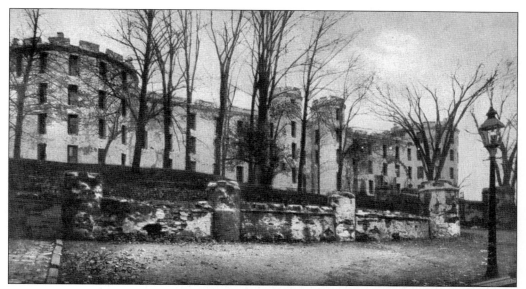

The Oread Collegiate Institute was founded by noted abolitionist Eli Thayer as a women's college. One 1934 history of Worcester County noted that the institution "was the national pioneer in colleges established exclusively for women at the time of its opening on May 14, 1849." The college closed in 1881 and afterwards housed a domestic science school. This unique structure was demolished in 1934. Oread Street and Castle Street owe their names to the once-venerable educational edifice.

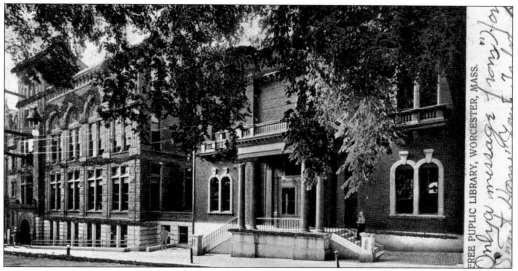

There was a library in Worcester as early as 1793, but it soon closed. The foundations of the current Worcester Public Library were the Worcester Lyceum of 1829 and the Young Men's Library Association of 1854, which consolidated their resources in 1859. To this was added the private library of Dr. John Green, who gave $30,000 to support the collection. In 1861, the library opened on Pearl Street in the second building seen here on the right. The adjoining estate was purchased for the expansion of the library, and an addition was built in 1891, as seen on the right. The library remained at this location until the early 1960s, when a new facility was built at Salem Square.

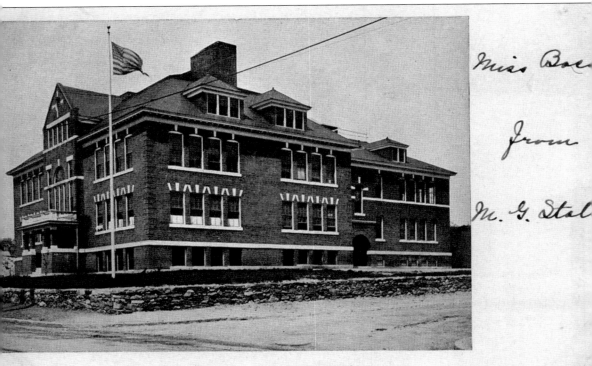

GATES LANE SCHOOL, WORCESTER, MASS.

Gates Lane School was occupied in 1898 as a temporary branch high school before reverting to an elementary school that same year. Due to neighborhood growth in the Webster Square area, the school was enlarged in 1903, 1922, and 1925. For most of its existence, it served children from kindergarten through eighth grade. The original building, shown here, was demolished in 1994 and replaced with the current structure on the same site. This *c.* 1903 postcard, showing the newly enlarged building, was given to teacher Miss Bacon by the school's first principal, Mary G. Stalker.

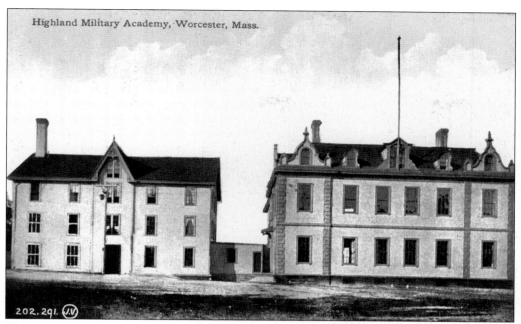

Highland Military Academy, Worcester, Mass.

202. 291. JV

This view shows the Highland Military Academy, which was located where Military Road joined Salisbury Street. Opened in 1856, it provided a strict military training for young men and also offered advanced study in surveying, civil engineering, and natural science.

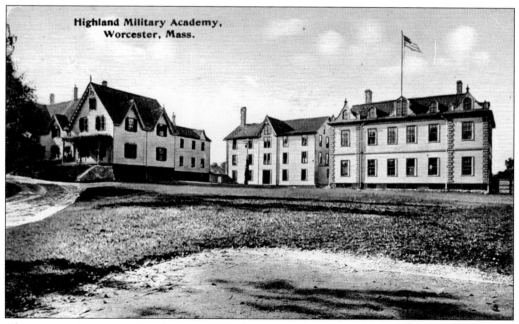

Highland Military Academy,
Worcester, Mass.

This postcard, sent on October 23, 1916, shows a wider view of the academy, which was a boarding school for the many boys who came from great distances to attend.

Entrance to Holy Cross College, Worcester, Mass.

This rare view from 1907 shows the entrance to the College of the Holy Cross.

Eight

CITYSCAPES

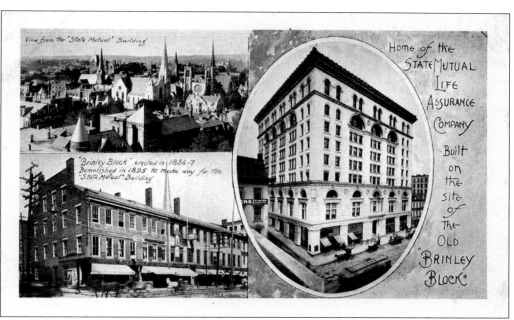

Collectible postcards often highlight popular or unique city landmarks. The State Mutual Life Assurance Building was the focus of this *c.* 1905 card. When it was finished, this new headquarters of the city's premier insurance company was considered one of the most modern of its day and a symbol of the commercial and financial success of the burgeoning industrial city of Worcester. The building remains a downtown landmark.

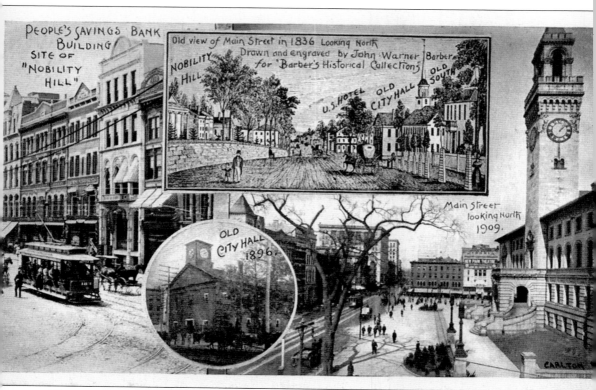

PEOPLE'S SAVINGS BANK BUILDING SITE OF "NOBILITY HILL"

Old view of Main Street in 1836 Looking North
Drawn and engraved by John Warner Barber
for Barber's Historical Collections

NOBILITY HILL

U.S. HOTEL OLD CITY HALL OLD SOUTH

Main Street looking North 1909.

OLD CITY HALL 1896.

CARLTON

The transition of the heart of downtown is captured in this souvenir postcard. At one time, mansions lined Main Street across from the town hall. Located upon an incline, this prestigious block became known as Nobility Hill. The increasing commercial and industrial success of the new city resulted in the removal of both the mansions and the old town hall. In their place, rows of commercial buildings and a new city hall became symbols of the industrial success of Worcester.

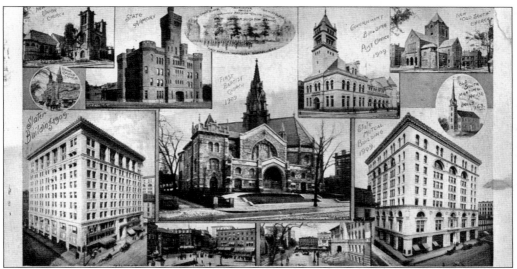

Municipal buildings, commercial establishments, and houses of worship form a myriad of images that highlight scenes of the downtown commercial area. In the center is the First Baptist Church, an ornate Main Street edifice that was destroyed by fire in 1937 and replaced with a more modern structure on Salisbury Street. Second from the left at the top is the Worcester Armory at Lincoln Square, and second from the right at the top is the post office. Constructed at Federal Square in the 1890s, the post office was considered both unsightly and impractical. During the 1930s, it was replaced with a structure that still occupies the site today.

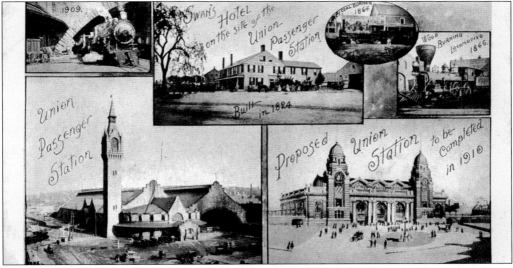

A visual history of Worcester rail service is shown on this c. 1910 postcard. Worcester's future was made secure with the introduction of rail service in 1835. By 1850, the Blackstone Canal was defunct and the city was developing into an industrial center. The need for a large urban transportation center led to the construction of the first Union Station in 1873. By the time this postcard was printed, a proposed replacement station was being discussed. The new station was eventually constructed across Washington Square, and the old station was demolished. The impressive Romanesque tower of the old station stood until the construction of Interstate 290 forced its demolition in the late 1950s.

1909.
Combination Wagon Beacon St

Rapid 4

1909.
OLD LADDER 3 at HEAD

Hose 2

Hose

EA
2

The Worcester Fire Department maintained a large contingent of horses, used to haul the heavy and cumbersome steamers and ladder wagons, until the arrival of motorized fire apparatus in the 1920s. In this *c.* 1909 montage, the various hose and ladder departments are seen outside their respective stations. Established in 1835, the department has seen its share of disastrous

114

1909.
Engine 2 Beacon St

Hose 4

Hose 7

conflagrations, including the Knowles Building fire of 1921, the factory fires spawned by the infamous 1938 New England hurricane, and the massive 1991 fire that largely destroyed the vacant Worcester State Hospital complex.

On this *c.* 1910 postcard, a portrait of Fire Chief George S. Coleman is flanked by various views of the Worcester Fire Department. By the time this postcard was issued, a network of stations and call boxes was in place throughout the city to quickly warn both citizens and department personnel of emerging fires. Despite safety precautions and warning systems, the risk of loss of life is an ever-present reality. The city has experienced several deadly fires, including the Eden Street fire in 1929, Pleasant Street fire in 1940, and the Worcester Cold Storage Building fire in 1999.

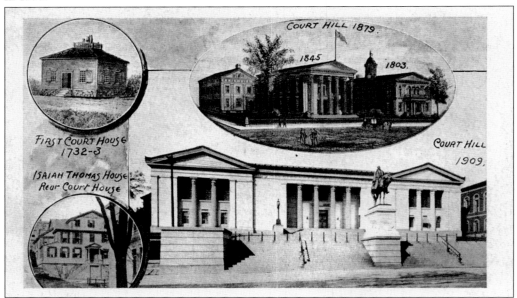

Worcester was made the seat of the county court with the establishment of Worcester County in 1831. Since that time, the courthouse has been located primarily at Lincoln Square. Historical views of Worcester's courthouses are the focus of this *c.* 1909 mosaic.

Nine

SOCIAL COMMENTARY

This birthday greeting was postmarked from Worcester and sent to Mrs. Frank Tucker of Rochdale on February 14, 1912. Postcard birthday greetings were extremely popular at that time, and today they remain an area of topical collecting.

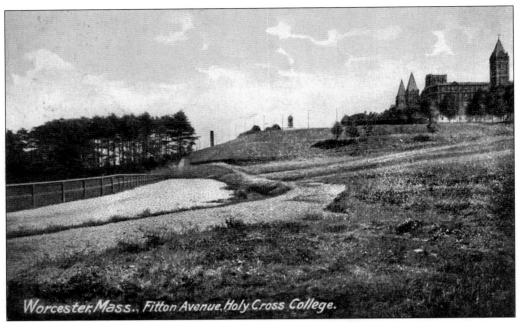

Worcester, Mass., Fitton Avenue. Holy Cross College.

The following cards have been selected to illustrate some of the messages sent between friends and relatives at the beginning of the 20th century. Often these messages focused on simple everyday thoughts, with the weather being a favorite topic for most. On the back of this rare card, which shows Fitton Avenue at the base of Holy Cross College, the message states, "Dear Jennie I waited long in answering your postal I am slow but sure. from your friend, A. Olson." It is interesting to note that the card was sent from Worcester to Greendale.

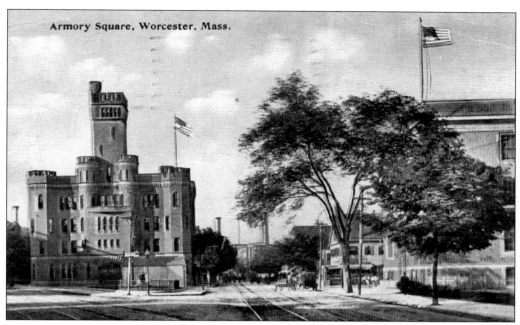

Armory Square, Worcester, Mass.

In this view of Armory Square, looking down Grove Street toward the American Steel and Wire north works plant, the Worcester Boys Trade School can be seen on the right, with a diner directly beyond. The message on the back is addressed in the more formal style of the period. "Dear Husband, Mother and I am here in Worcester to see the Dr. I will be home Thurs sure Lizzie wants to go back with me don't know whether she will or not. Love from Rosa."

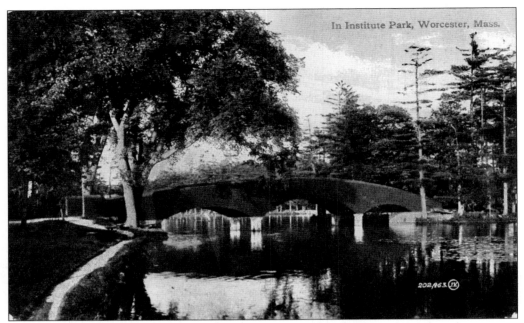

202,463.

The Institute Park bridge is in the center of this serene water view. This wooden bridge was destroyed by arson in the 1920s and was not rebuilt. There has been talk of a similar bridge being constructed to connect to the island at another location. The message states, "Arrived in W – 12:45, just had our dinner, are in one of the stores. We had a nice trip but I was froze as usual. Lena." It makes one wish she had mentioned which store she was in.

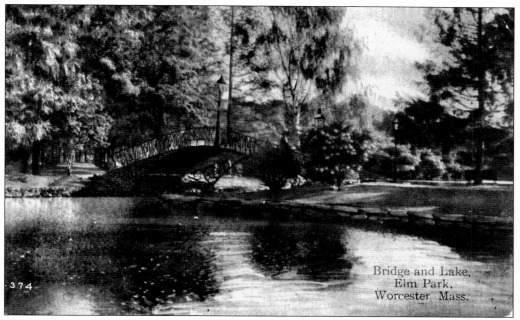

This 1913 view of Elm Park shows the ornate bridge that was so familiar to park visitors in the early 1900s. Then, as now, the park and its bridges were a popular location for wedding photographs. The message, dated May 22, 1913, reads, "Wonder if the cool damp weather has caused the pen to rust? Hope you are fine, I am fairly good for me. L F." It appears that even a century ago, people chided each other about the lack of timeliness in answering a note.

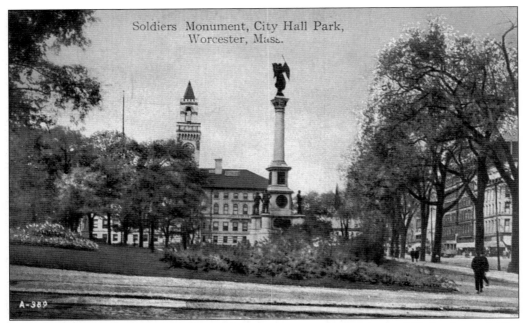

Soldiers Monument, City Hall Park,
Worcester, Mass.

This 1910 view of city hall and the Soldiers Monument shows a beautifully landscaped City Hall Park, seen from what is today the Galleria side. Front Street is to the right. The common is currently under construction and, when finished, will result in a view close to the one on this card. The message was a simple one that illustrated the transportation concerns of the time: "Arrived safely The train was on time. Celia."

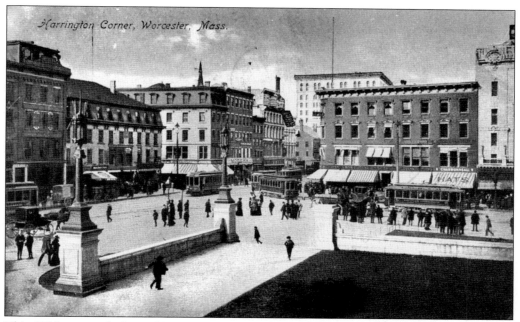

This 1909 postcard view of Harrington Corner, as seen from the city hall steps, shows that trolleys were the main form of transportation in the early 20th century. The writer of this card expressed his sentiments as briefly as possible, but he made his feelings clearly known: "Gone but not forgotten Joe." If you look closely at the left side of the back, you will see that this card was printed in Germany, where the majority of cards were printed at that time.

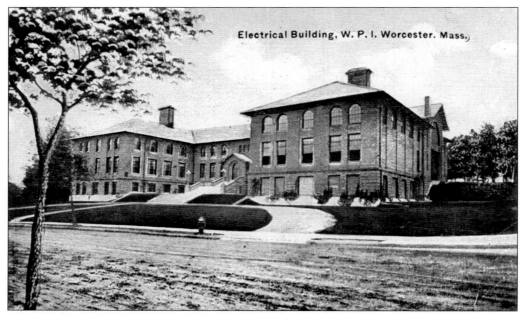
Electrical Building, W. P. I. Worcester. Mass.

In 1907, the country's finest and largest electrical engineering building was built at Worcester Polytechnic Institute. The department, which was first housed in the corner of the basement of Boynton Hall and later in the newly built Salisbury Laboratories, expanded greatly in its new space and became nationally recognized. Postmarked August 25, 1913, this card from Lewis has a brief but informative message: "We received your P. C. & we are glad to hear you are O.K. We are going away Wed Aug 27th untill Labor Day to New York & Bridgeport to Fred Eastwood's, so will not be home when you come. Name of our St changed to 56 Dorchester St." Postcards are often helpful in researching the history of an area because of the many detailed pieces of information passed back and forth by the correspondents.

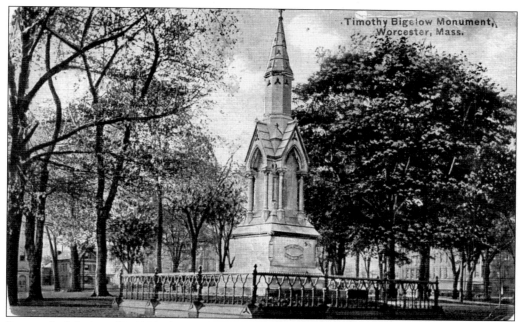

Timothy Bigelow Monument,
Worcester, Mass.

Postmarked August 17, 1911, this card shows the Timothy Bigelow Monument, located on the common. The monument is a memorial to Col. Timothy Bigelow, who farmed the common area and left to answer the call at Lexington on April 19, 1775. Sadly, Bigelow died in jail and in debt. The message on the back of the card gives us a glimpse of travel at the time: "Dear Miss Lewis, If the weather is fine Sunday we are thinking of taking a trolley ride to Athol and if we do, we'll call on you. Myrtle Reed Hatch."

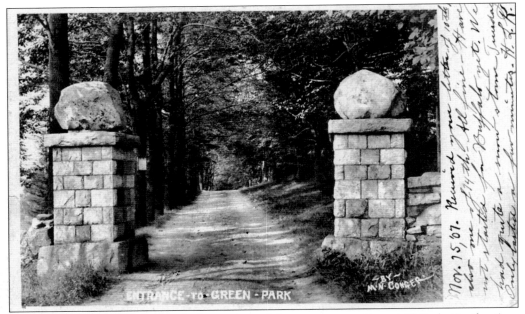

This is an uncommon 1907 real-photo view of the entrance to Greenhill Park. By the time this card was sent in November 1907, it was permissible to write messages on the back, along with the address, but the sender wrote the message on the front, probably out of habit. The message, dated November 15, 1907, reads, "Received your letter of 10th, also one of 14th. All fine – Have not started for Buffalo yet. We had quite a snow storm Tuesday. Only lasted a few minutes. H. L. K."

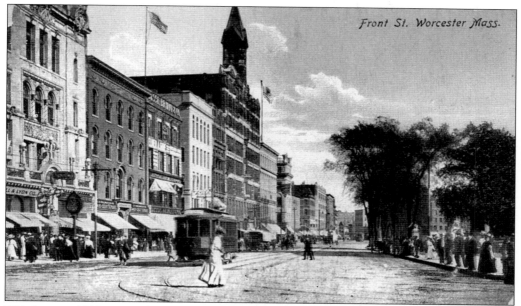

This January 1909 postcard view, looking toward Union Station, shows a busy Front Street. This section of the city was part of the plan being developed for the creation of City Square. Plans called for the connection of Front Street with Washington Square. The card was not postmarked but was probably included in an envelope with a letter or hand delivered. The message, dated January 24, 1909, filled the entire back. It reads, "Dear Friend – Thank you for fine cards Thank you, again, for your kind thoughts about passing my exams. Awfully glad you're not deaf dumb or blind. I wear glasses too. Delighted to know that you are at least a Christian and also a Prot. E. Of course, I go to church when I'm home in Bristol but in W, I go when I can I've been to church here, though, don't let that worry you."

Y. W. C. A. Chatham St., Worcester, Mass.

This 1910 postcard is a view of the YWCA on Chatham Street. The building, much reduced, is now home to the Performing Arts School of Worcester. This card has an interesting message on the reverse that illustrates how little most people traveled in the early 20th century. It also makes clear that the average person's view of the world was centered very close to home. "I can scarcely realize I am so far way from home. Mr. & Mrs. Purdy a quite well. I like it up he very much. Annie B." As can be seen from the postmark, Annie was living in Worcester and writing to what seemed like a faraway place: Norwalk, Connecticut.